IMAGES
of America

MARYLAND'S
FORESTS AND PARKS

A Century of Progress

ON THE COVER: A RELAXING SUMMER DAY IN PATAPSCO. Campers relax in the shade in front of their World War I army-style wall tent at the Patapsco Forest Reserve during the 1920s. Baltimoreans often spent up to six months to a year living along the Patapsco River rather than brave the city heat. (Maryland Department of Natural Resources.)

IMAGES
of America

MARYLAND'S
FORESTS AND PARKS
A Century of Progress

Robert F. Bailey III
on behalf of the
Maryland Department of Natural Resources

ARCADIA
PUBLISHING

Copyright © 2006 by Maryland Department of Natural Resources
ISBN 978-0-7385-4351-2

Published by Arcadia Publishing
Charleston, South Carolina

Printed in the United States of America

Library of Congress Catalog Card Number: 2006930231

For all general information contact Arcadia Publishing at:
Telephone 843-853-2070
Fax 843-853-0044
E-mail sales@arcadiapublishing.com
For customer service and orders:
Toll-Free 1-888-313-2665

Visit us on the Internet at www.arcadiapublishing.com

CONTENTS

ACKNOWLEDGMENTS

Many people provided invaluable assistance along the way. First I'd like to thank Maryland Park Service historian Ross Kimmel, who has been a steady and reliable source of help and inspiration since he first allowed me to raid his cubicle for source material three years ago. Without his assistance, it is unlikely I would have had the opportunity to work as a historian with the Maryland Park Service. Offutt Johnson, former assistant director of Program Open Space and naturalist at Patapsco Valley State Park, was equally helpful—always willing to go above and beyond to find important pieces of the historical puzzle. The same can be said for Green Ridge State Forest manager Francis Zumbrun, whose enthusiasm for and knowledge of Maryland forestry is inspirational. Thanks also go to forester Jack Perdue, who helped me fill in some of the proverbial blanks in a pinch. I would also like to thank Rick Barton and Rusty Ruszin for providing me the patience and flexibility needed to complete this project. I'm grateful to the Maryland Park Service field staff, who were willing to provide assistance at a moment's notice. They include (in no particular order) Steve McCoy, Stephanie McHenry, Cindy Hawkins, Marti Woodfield, Courtney Bryan, Christina Holden, Mike Gregory, Gary Burnett, Caroline Blizzard, Eric Creter, Erin Thomas, Bob Cantin, Roberta Dorsch, Larry Martin, Jeremiah Hornbaker, and Don Myers. I apologize to anyone I left out. Among others I'd like to thank (again, in no particular order) are Silas Sines Jr., Ed Whyte, Barbara Garner, Ward Wensch, Mark Hollis, Sandi Trent, Robert Hunter, Lauren Bobier of Arcadia Publishing, Jeff Korman of the Enoch Pratt Free Library, Heidi Herr of the Johns Hopkins University Library, Gretchen Shaffer of the Garrett County Historical Society, Charlie Cadle (formerly of Department of Natural Resources' Capital Programs), Anne Hairston-Strang, Pam Cressman, Pam Kelly of the Maryland Forest Service, Prof. Geoffrey Buckley of Ohio University, Tom Gamper of the Maryland Parks Advisory Commission, Special Collections staff at the University of Maryland–Baltimore County, and Kirk Rodgers, grandson of F. W. Besley. I'd also like to thank everyone who served on the Maryland Forest and Park Centennial Committee. And finally, I'd like to thank Mary Calomeris, whose love, support, and honest appraisals of my work have helped me immeasurably.

INTRODUCTION

While this book is hardly a comprehensive history, it is intended to stand as a testament to the efforts of all those who have worked for Maryland State forests and parks over the past century. As the Maryland Forest and Park Services celebrate their centennial, we have an opportunity to reflect on where these agencies came from and contemplate where they are going in the future.

Forests and parks are places that, for many, possess an intrinsic value that is impossible to quantify. For some, they are places for spiritual renewal. For others, they are places where the natural environment is protected. For others, they are places where the past comes alive. And for others still, they are places where families and friends go to reconnect. Those who have worked for the Maryland Forest and Park Services often find that their jobs are about more than punching a time clock and collecting wages. The jobs are full-time and lifetime commitments that border on obsession—albeit a healthy one.

The Maryland Forest and Park Services are fascinating on two levels. Both agencies maintain and operate many of the most important historic, cultural, and natural icons in Maryland, such as Fort Frederick and Muddy Creek Falls, and provide the public with an opportunity to appreciate and enjoy the state's human and natural heritage. The agencies themselves, however, also have an interesting institutional history. Maryland has one of the oldest state park and forest systems in the United States. Starting with creation of the State Board of Forestry in 1906, Maryland has played a leading role in protecting the environment while pioneering outdoor recreation.

Though Maryland was not the first state to build state forests and parks, it was among the first and at least two decades ahead of most others. The agencies' origins were decidedly forest conservation–oriented. Observers in the late 19th century and early 20th century noted the rapid disappearance of tree cover in many states, including Maryland. Much of this destruction was due to forest fires and excessive logging. Conservationists believed that a more rational management system based on science was needed to protect the state's remaining forests. Disparate influences came together in 1906, when Gov. Edwin Warfield signed an act creating the State Board of Forestry. Chapter one highlights the key figures associated with this early period, including William Bullock Clark, Robert Garrett, and Joseph B. Seth. Chapter two emphasizes the efforts of F. W. Besley, Maryland's first state forester, to spread the gospel of scientific forest management through a wide variety of initiatives through the 1920s, including establishing a force of volunteer forest wardens, building fire towers, and developing a state forest nursery. Chapter three highlights the growth of outdoor recreation and historic preservation in Maryland between 1910 and 1930, particularly at Patapsco but also at Swallow Falls and Fort Frederick. Chapter four is entirely devoted to the efforts of the Civilian Conservation Corps, a Depression-era federal public works program that forever transformed Maryland's forests and parks into more modernized, automobile-friendly facilities. Chapters five and six cover the rapid expansion and development of state forests and parks after World War II through the early 1970s. In particular, these chapters illustrate the growing demand for recreational facilities and the Department of Forests and Parks' efforts to meet those needs. Chapter seven details many of the challenges that Maryland forests and parks faced in the last quarter of the 20th century and continue to face in the early 21st century.

The majority of photographs used in this book were taken from the collections maintained by the Maryland Forest and Park Services and from the Maryland State Archives. Virtually all of the Board of Forestry's original prints and negatives taken between 1906 and 1919 were lost in a fire in 1919. State forester F. W. Besley and his assistants Karl Pfeiffer and Henry C. Buckingham snapped most of the photographs taken from 1919 to 1950. Most photographs from 1950 to 1970 were taken by former state forester Adna R. Bond and forest and park public relations officer Earl Mentzer. Maryland Department of Natural Resources field staff took most of the post-1970 photographs.

To save space, many photograph credits are indicated by acronyms. Photographs that belong the Maryland Department of Natural Resources are labeled "DNR," Enoch Pratt Free Library are labeled "EPFL," Johns Hopkins University are labeled "JHU," Garrett County Historical Society are labeled "GCHS," and the Maryland State Archives are labeled "MSA."

One

A CRISIS IN MARYLAND'S FORESTS

At the time of the first English colonization in the early 17th century, forests covered 95 percent of the present-day state of Maryland. By 1900, the state's forest cover had been reduced to a mere 35 percent. European (and African) settlers, seeking to carve an existence out of the Maryland forests by clearing the land and establishing farms, had caused most of the devastation. Land clearing, however, slowed after 1850. In some parts of Maryland, especially in Western Maryland, forestland began to recover.

In the late 19th century, however, a new development jeopardized Maryland's remaining forests. Timber companies, motivated by profit and aided by new technology, threatened to reduce Maryland to a denuded and barren landscape. Few companies saw reason to cut trees selectively or to replenish their timber harvests by planting new trees. To meet this new danger, several progressive leaders took action to save Maryland's remaining woodland and, perhaps, to replenish the state's forests for the future.

Beginning in 1900, state geologist William Bullock Clark, a professor at Johns Hopkins University, encouraged the Forestry Division of the U.S. Department of Agriculture (ancestor to the modern U.S. Forest Service) to study Maryland's declining forests. These studies, coordinated by George B. Sudworth and Hugh M. Curran, convinced Clark to push for stronger forest conservation laws. Meanwhile, in 1905, William McCulloh Brown, a surveyor from Garrett County, won a seat in the Maryland State Senate. A single-term senator, Brown introduced a bill calling for the establishment of a state board of forestry. The proposed board would be vested with the authority to combat forest fires, rein in cut-and-run timber companies, advise private landowners how to scientifically manage their timber, and maintain state-owned forest reserves and state parks. One year later, in 1906, brothers Robert and John Work Garrett donated 1,917 acres of cutover Garrett County land to the state for the establishment of a forest reserve. With the assistance of senate president Joseph B. Seth of Talbot County, Brown's legislation passed the general assembly on March 31 and was signed into law by Gov. Edwin Warfield on April 5, 1906.

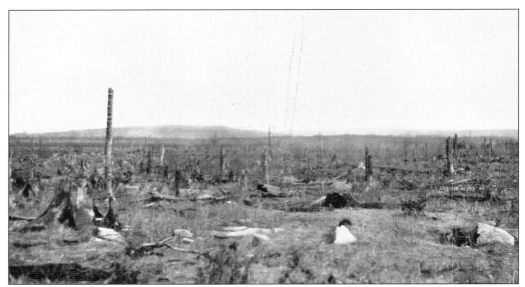

A DEVASTATED LANDSCAPE. Ironically, because of a fire at the Board of Forestry's headquarters in 1919, few photographs of Western Maryland's devastated forests remain. This photograph however, taken in Garrett County in 1922, conveys the level of desolation in Maryland's once-lush Appalachian forests by the early 20th century. The cut-and-run timber companies have left virtually nothing but stumps. (DNR.)

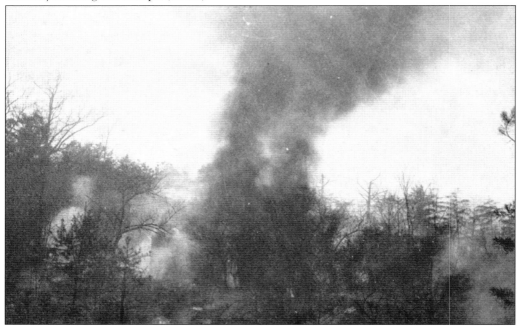

FOREST FIRE. By 1900, a faith that science could solve all problems permeated the nation's intellectual and political elite. Many came to believe forest fires could not only be controlled, but that the forests themselves could be made into efficient and profitable crops. This faith helped lead to the creation of the U.S. Forest Service in 1905 and the Maryland Board of Forestry in 1906. (DNR.)

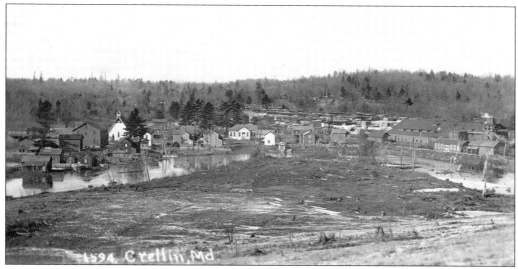

CRELLIN LUMBER MILL. In Garrett County, the Baltimore and Ohio Railroad (B&O) spun off dozens of small branch lines, including Preston Railroad, which penetrated deep into the hills of Preston and Tucker Counties in West Virginia. The Preston Railroad funneled its timber to this mill at Crellin, Maryland. As this 1912 photograph indicates, the mill owners saw little reason to replant even nearby harvested tree stands. (GCHS.)

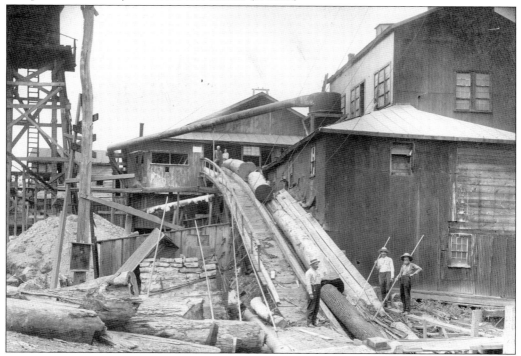

CRELLIN MILL CONVEYOR BELT. At its peak, the Kendal Lumber Company's 64-inch circular saw and 8-foot band saw could cut 75,000 board feet (over 1,000 trees) a day. Seen here in May 1915, the mill employed between 275 and 750 men (depending on demand) and operated until 1925. (GCHS.)

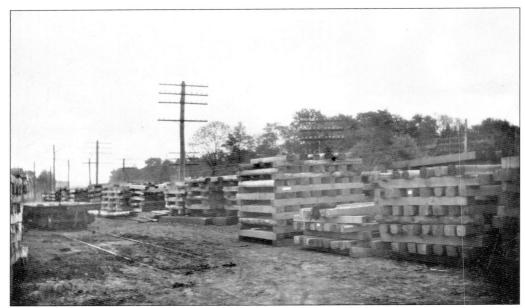

RAILROAD TIES AT LAUREL. Among the biggest wood customers were railroads, which utilized wood for cross ties, buildings, equipment, and (in some cases) fuel. Until the advent of creosote to treat wood in the early 20th century, railroads went through ties at an astonishing rate. In May 1921, new railroad ties are stacked along the B&O's Washington Branch near Laurel, ready to be laid. (DNR.)

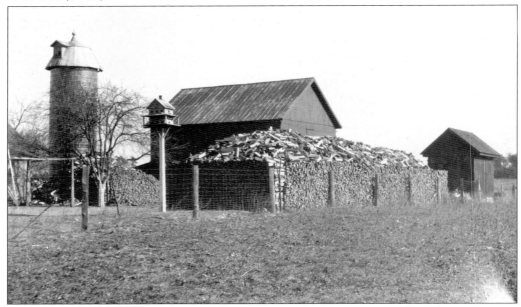

FIREWOOD. Domestic U.S. wood production reached its zenith in the early 20th century. Not only did wood provide materials for making everything from houses to paper, but it was also the primary household heating fuel. So voracious was the nation's appetite for wood that there was talk of a "timber famine." This Preston farmer's fuel bin (pictured on February 6, 1926) illustrates the demand for wood. (DNR.)

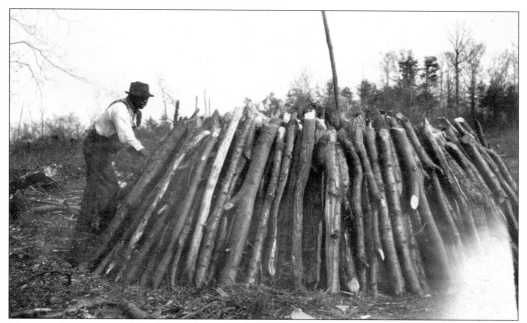

MAKING CHARCOAL. Until the advent of electric and gas heat, most Americans heated their homes with either firewood or charcoal—which is derived from wood. Making charcoal, however, was a tedious process that often required at least a week. Employing a centuries-old method, a worker at Lake Shore in Anne Arundel County prepares a charcoal-making pit on May 20, 1920. (DNR.)

SOIL EROSION. Fires were not the only consequence of forest neglect. Denuded landscapes caused rainwater to speed toward streams. The result was eroded hillsides, clogged stream channels, filthy water, and largely absent wildlife. Here the State Board of Forestry's survey team has photographed the effects of unregulated iron mining in Anne Arundel County in the 1920s. (DNR.)

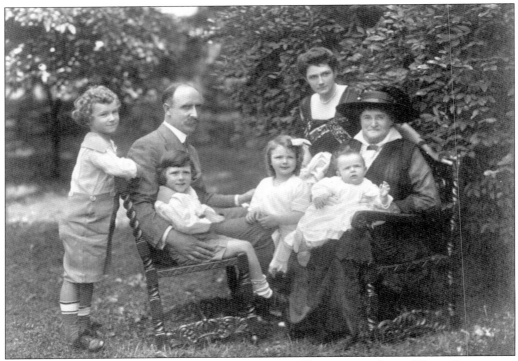

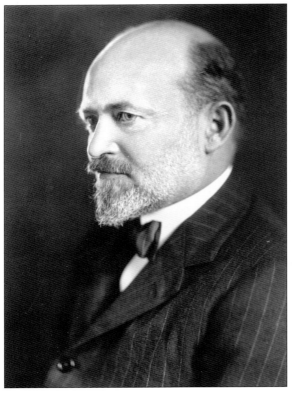

ROBERT AND JOHN WORK GARRETT. Grandsons of B&O president John Work Garrett, the Garrett brothers spent their lives in the public spotlight. John (left) served as a minister in the U.S. Foreign Service. Robert (above with his family) became a progressive reformer. In particular, Robert promoted outdoor recreation in Baltimore City. He served as president of Baltimore's Playground Athletic League and is reputed to have brought the Boy Scouts of America to the city in 1910. A failed political candidate, Robert nevertheless wielded influence in state politics. It was Robert's (and John's) donation of 1,917 acres of Garrett County woodland to the State of Maryland that helped lead to the establishment of the State Board of Forestry in 1906. Robert also played a key role in expanding and transforming the Patapsco Forest Reserve as a state-run park beginning in 1912. (Evergreen House/JHU.)

WILLIAM BULLOCK CLARK. A Vermont native, Clark earned a doctorate of science in Germany before becoming a professor at Johns Hopkins University in 1887. At Hopkins, Clark became director of the Maryland Weather Service in 1892 and state geologist in 1896. As state geologist, he commissioned the U.S. Department of Agriculture to study Maryland's forest resources; then, in 1906, he became the State Board of Forestry's first executive director—a position he held until his death in 1917. (JHU.)

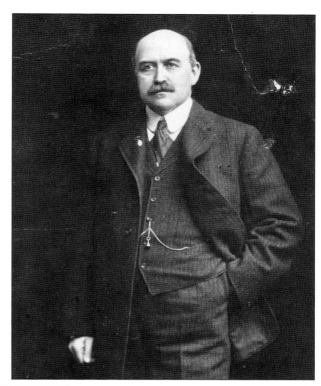

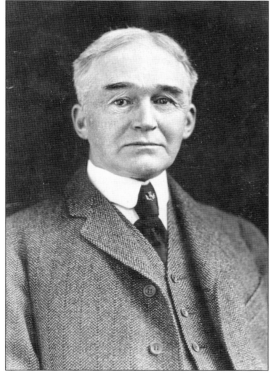

WILLIAM McCULLOH BROWN. A surveyor from Garrett County, Brown was the key figure responsible for establishing the Maryland State Board of Forestry. Elected to the state senate in 1905, Brown introduced the forestry board legislation in 1906. He later served on the State Board of Forestry (with Robert Garrett) and took a strong interest in the state's acquisition of historic Fort Frederick. He also helped settle a border dispute between Maryland and West Virginia in 1910. (MSA.)

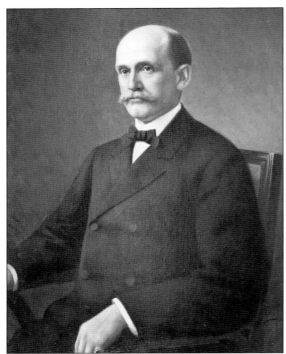

JOSEPH B. SETH. An influential Eastern Shore politician, Seth championed conservation and outdoor recreation. As president of the Baltimore and Eastern Shore Railroad, he was among the first to promote Ocean City as a vacation resort. In the early 20th century, Seth served as head of the Maryland Oyster Navy, forerunner of today's Maryland Natural Resource Police. As president of the state senate, Seth pushed through the act creating the State Board of Forestry. (MSA.)

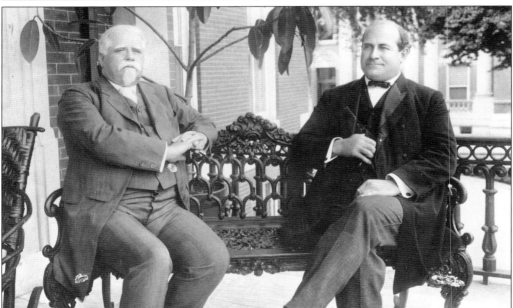

EDWIN WARFIELD. A progressive governor, Warfield (left) fashioned himself as a compromise between the Democratic political machine and the reform-minded Republicans. Despite being a Democrat himself, Warfield vigorously opposed Democratic bosses, including Arthur Pue Gorman. Warfield is most famous for his opposition to the failed Poe Amendment (which would have disenfranchised African Americans) and his love for historical preservation. He is pictured here with William Jennings Bryan in 1905. (MSA.)

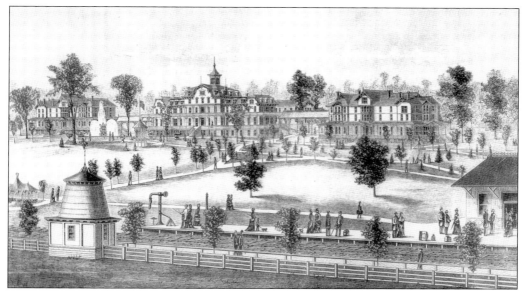

DEER PARK HOTEL. While European vacations were fashionable among 19th-century elite, many also traveled to exclusive mountain resorts such as the one pictured here near Oakland, Maryland. Typically railroads such as the Western Maryland Railway and the B&O, vying for high-class passengers, operated these resorts. The B&O's Deer Park reached its peak of popularity in the 1880s but was in significant decline by 1900. (EPFL.)

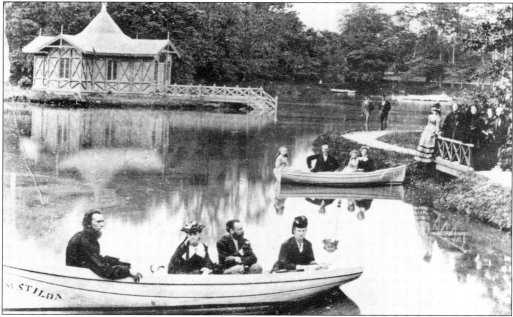

DRUID HILL PARK. Nineteenth-century urban elites promoted healthy and constructive (and alcohol-free) recreation among all classes. The result was the urban park, including New York's Central Park and Baltimore's Druid Hill Park. Purchased by Baltimore City in 1860, Druid Hill's picturesque gardens became popular for strolling and horseback riding. The lake, pictured here in 1870, became popular for boating in the summer and ice-skating in the winter. (EPFL.)

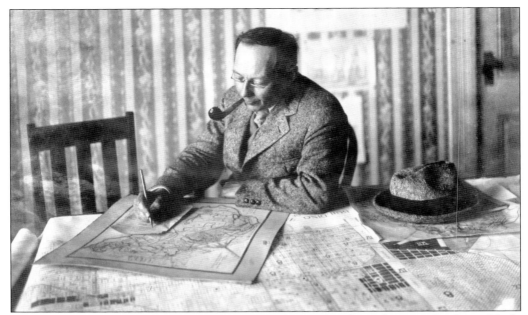

FREDERICK LAW OLMSTED JR. Son of the famed architect who planned New York's Central Park, Olmsted Jr. and his brother, William, were contracted by the Baltimore Municipal Art Society in 1902 to create a comprehensive park development plan for Baltimore City. Olmsted's plan called for the establishment of community playgrounds, larger parks with athletic fields, and stream valley parks and established the fundamental basis of today's Baltimore City park system. (National Park Service, Frederick Law Olmsted National Historic Site.)

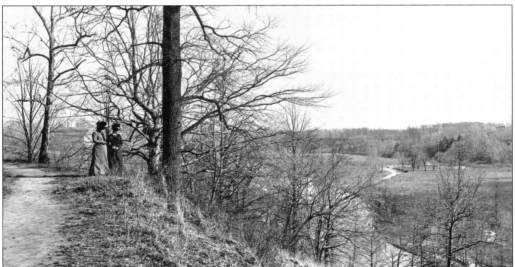

GWYNNS FALLS PARK AND TRAIL. The Olmsteds called for Baltimore City to establish stream valley parks along the Jones and Gwynns Falls and the Gunpowder and Patapsco Rivers. These parks were intended to protect water resources while providing the public recreational opportunities. The Jones and Gwynns Falls became city parks, while Patapsco and Gunpowder became state parks in 1907 and 1960 respectively. On April 5, 1901, two women pause while strolling along the Gwynns Falls. (EPFL.)

Two

FRED W. BESLEY AND SAVING MARYLAND'S FORESTS

In 1906, the State Board of Forestry hired Maryland's first state forester, Fred W. Besley. A protégé of famed U.S. forester Gifford Pinchot, Besley served with distinction as state forester from 1906 to 1942.

At first, Besley faced the unenviable task of protecting Maryland's 2.2 million acres of forestland with a skimpy budget and staff made up mostly of volunteers. Over the next 36 years, however, Besley transformed the tiny State Board of Forestry into the Department of Forests and Parks—one of the most powerful natural resource agencies in Maryland at the time of his retirement. His vision and tireless dedication laid the groundwork for the state forest and park system people enjoy today. In the process, Besley compelled countless Marylanders to embrace a forest conservation ethic.

Still most forestland remained in private hands. Throughout his tenure, Besley's mission centered on educating Marylanders about the benefits of caring for forests. He worked closely with private landowners and timber companies, supplying them survey data and advice on how to utilize their forest resources responsibly. A flooded and unregulated agricultural market (after 1920), combined with the nation's appetite for wood, challenged Besley's efforts. Eventually failure to convince farmers to change their practices, especially in Western Maryland, led to massive expansion of state-owned timberland beginning in 1929 and continuing into World War II. Besley controlled a mere 1,917 acres in 1906; by 1942, his agency managed over 117,000 acres.

From the start, Besley's largest priority was fighting forest fires. Like most foresters at the time, Besley viewed trees almost strictly as a crop. Maintaining a commercially viable timber harvest dominated Besley's agenda. In the early 20th century, foresters like Besley obsessed over preventing all forest fires. No expense was spared. In Maryland, Besley set up a system for fighting and controlling forest fires by establishing a statewide network of fire watchtowers and organizing a force of over 300 fire wardens. He regularly issued leaflets and made public-service announcements on Maryland's radio stations warning of the hazards of forest fires.

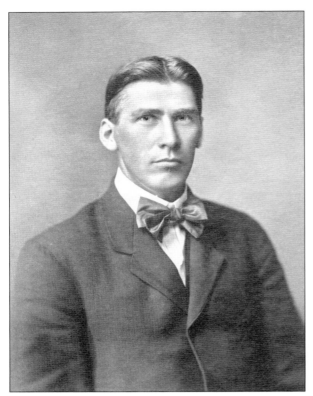

FRED W. BESLEY. A legend, Besley was the dominant force in shaping and developing Maryland state forests and parks from 1906 to 1942. Initially reluctant to become Maryland's first state forester, Besley feared that he would be subject to political influence. "My first reaction to the offer was no," he later recalled. "I knew something about politics in Maryland and I didn't want a political appointment. When I was assured it was independent of politics, I accepted." During Besley's 36-year tenure, he established state-of-the-art methods for controlling forest fires, compelled landowners to responsibly manage their timberlands, and established the first Maryland state parks and forests. Upon his retirement, Besley had the longest record of continuous service as state forester in the nation. Below, at age 84, Besley receives a certificate of recognition from Gov. Theodore R. McKeldin in 1956. (Besley-Rodgers family.)

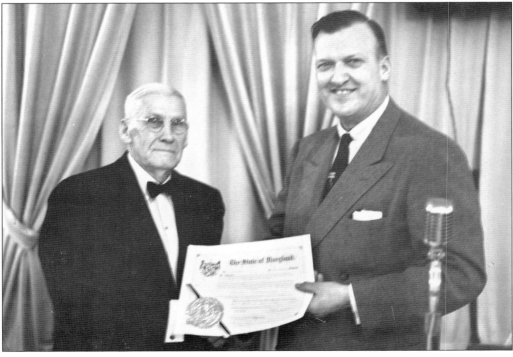

McCoy Hall. Even though McCoy Hall primarily housed Johns Hopkins University's humanities departments, it was also the home of the State Board of Forestry's central office from 1906 to 1919. The hall was located on Hopkins's old campus in downtown Baltimore. The building was named for John W. McCoy, a wealthy 19th-century merchant who took an interest in the university. (JHU.)

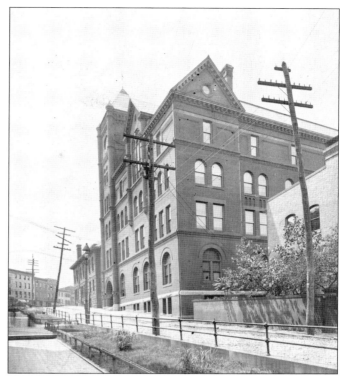

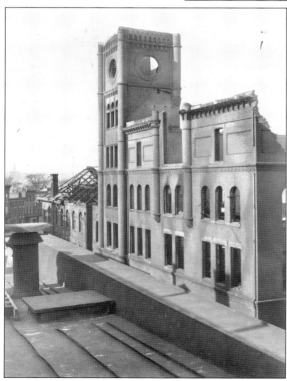

Burnt McCoy Hall. Shortly after Johns Hopkins University moved to its present-day Homewood campus, a devastating fire gutted McCoy Hall. Even though the building was largely vacant, the State Board of Forestry had not yet cleared out its records. Virtually all non-published material, including hours of survey data and thousands of photographs, was lost. (JHU.)

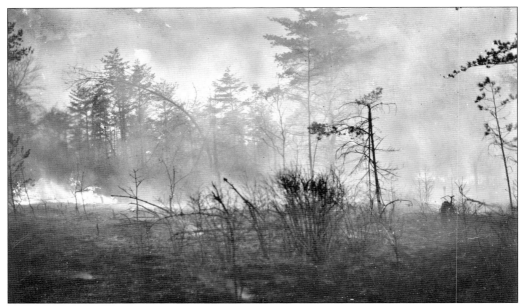

FOREST FIRE. Early-20th-century foresters viewed fires as the ultimate threat. Over 30,000 acres a year burned in Maryland annually, destroying thousands of dollars of property. Here a fire rips through Beltsville in Prince George's County, ultimately burning 1,000 acres on April 17, 1926. Preventing scenes like this was Besley's ultimate objective. (DNR.)

SAWMILL. Mobile and efficient, sawmills such as this one in Zekiah Swamp in Charles County in July 1939 could reduce a forest to barren wasteland in a matter of days. As this photograph indicates, most of the buildings are improvised and temporary. Deep wheel ruts and puddles suggest that no effort has been made to install permanent roads. (DNR.)

Tools of the Trade. Nearly 30,000 acres of Maryland forest burned annually when Besley arrived in 1906. Besley's tools for fighting forest fires were decidedly primitive yet timeless. Pictured at Patapsco in 1928 are many tools that are still used to combat forest fires today. These include fire rakes, axes, cloth buckets (that could be collapsed when not in use), and, most importantly, Indian fire pump water carriers. (DNR.)

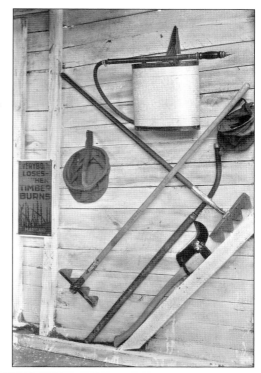

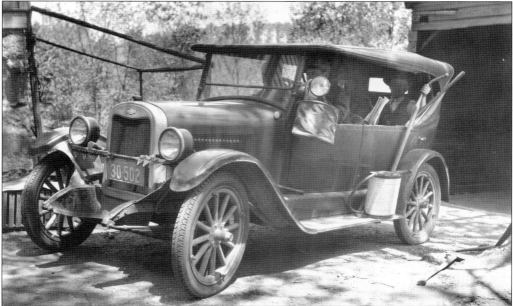

Firefighting Car. In later years, foresters used all-terrain vehicles such as Jeeps to chase down and fight fires. In 1928, however, their choices were narrower. Here the Maryland Department of Forestry has outfitted a privately owned Chevrolet with a fire rake (mounted on the front) and a searchlight. Other firefighting implements have been haphazardly added, including an Indian pump and cloth bucket. Additional tools are stored behind the driver's seat. (DNR.)

STATE OF MARYLAND

Forest Fire Laws

THE LAW IMPOSES:—

$1,000.00 fine, or one year's imprisonment, or both for carelessly or wilfully setting fire to any woods or brush on another's property.

The cost of extinguishing a fire and all damages resulting therefrom upon anyone who allows fire to escape from his land to the injury of adjoining property.

A fine for operating any coal or wood-burning engine in or near forest land without a spark arrester.

A fine for failure to extinguish or report to the nearest Forest Warden, any forest fire not under control.

THE LAW EMPOWERS THE WARDENS:—

To arrest, without warrant, violators of the Forest Laws.

To summon any man between 18 and 50 years to help fight fire. (Fine for refusal)

To requisition teams and other equipment.

To enter on any property without liability for trespass, when engaged in suppressing fires.

Posted by Authority of F. W. BESLEY, State Forester.

The State Board of Forestry, Baltimore, Md.

FOREST FIRE LEAFLET. Besley regularly issued leaflets highlighting the danger of forest fires. This leaflet from 1921 emphasizes the consequences for those caught starting forest fires, as well as consequences for refusing to assist in fighting fires if deputized by a forest warden. (DNR.)

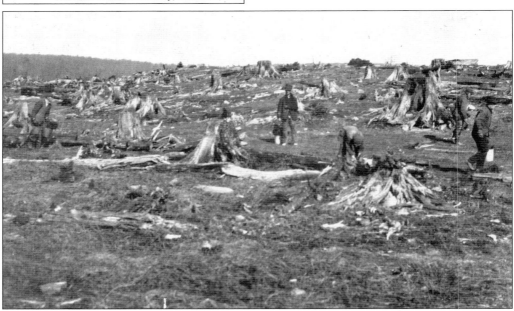

SWEPT CLEAN. Despite Besley's best efforts, forest fires remained a constant concern. Pictured here is a ravaged landscape in Garrett County in 1922, the result of slash-and-burn farmers and careless lumbermen. Given Besley's obsession with producing efficient forests with healthy young trees, scenes like this were all too common, much to his consternation. (DNR.)

KARL PFEIFFER. Pfeiffer served Maryland forests and parks for nearly half a century. A native of Brooklyn, New York, he started as an assistant with the State Board of Forestry in 1913 while attending Cornell University. He went on to serve as Besley's top assistant, becoming the first director of Maryland State Parks during the 1930s. During the 1950s, he earned the nickname "Mr. Patapsco" for his efforts to expand Patapsco State Park. (DNR.)

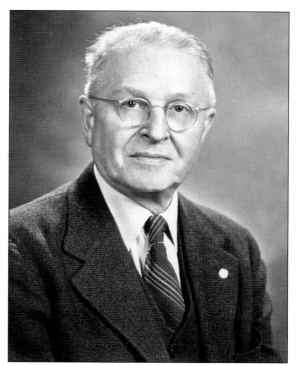

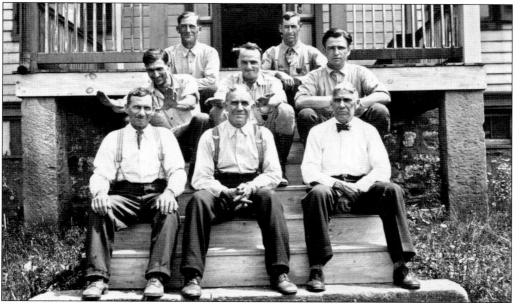

RESIDENT WARDENS. By the 1920s, Besley had assembled a group of professionally paid resident wardens to coordinate volunteer wardens as well as administer the expanding state forest and park system. Pictured at Herrington Manor in July 1932 are, from left to right, (first row) Robert O'Keefe, Abraham Lincoln Sines, and Besley; (second row) district forester Henry C. Buckingham, David O. Prince, and M. Carlton Lohr; (third row) Matthew E. Martin and Grover Cleveland Mann. (MSA.)

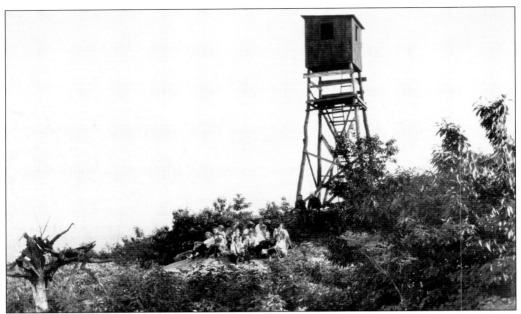

PITCH PINE TOWER. In 1915, the State Board of Forestry began to strategically place fire lookout towers across the state. They soon became the key tool in locating forest fires and remained so for half a century. The earliest towers were wood and barely peered over the treetops. In August 1921, the Camp Robin Hood girls have journeyed from nearby Herrington Manor to pose in front of a wood tower near the Maryland–West Virginia border. (EPFL.)

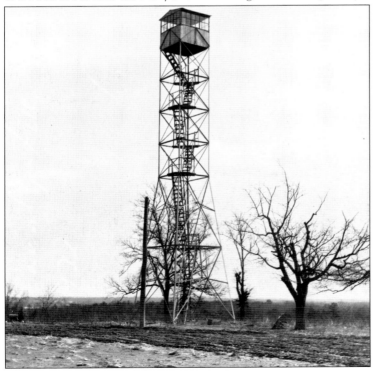

LONG HILL TOWER. By the 1920s, most fire towers were manufactured by companies such as Aermotor and assembled on location. Long Hill in Anne Arundel County, pictured in April 1923, was one of at least 34 towers built across Maryland. Many towers housed radio equipment and continued to function as communication towers long after their original purpose became obsolete. Long Hill later became the central communication center for the Maryland Forest and Park Service. (EPFL.)

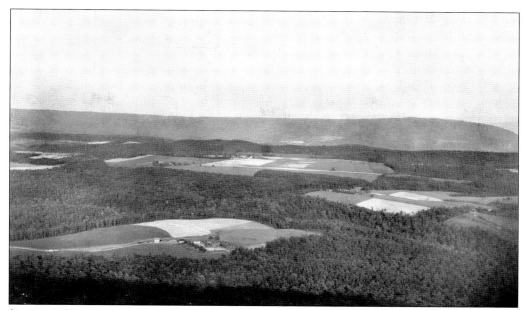

SIDELING HILL FROM TOWN HILL TOWER. Though watching for fires often led to boredom, fire watchmen (and women) nevertheless enjoyed spectacular scenery. Here is a view of the Sideling Creek valley east of Green Ridge State Forest, framed by Sideling Hill in the distance. Today Sideling Hill is noted for a spectacular cut that accommodates Interstate 68. This is how it appeared in July 1932. (DNR.)

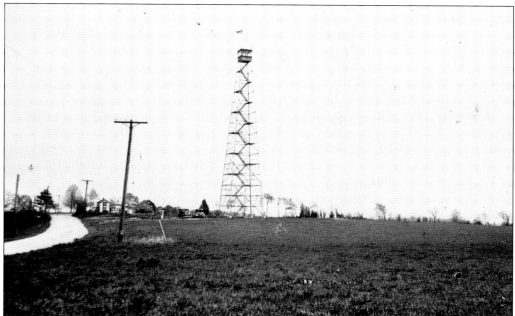

BURTONSVILLE TOWER. In what is now suburban Montgomery County, the Burtonsville lookout (pictured here in 1932) stood sentry 100 feet above the surrounding forest and farmland. Towers were initially linked to the ground by telephone but were later equipped with radios. The American flag indicates that the tower is manned. (DNR.)

THE FORESTS OF MARYLAND. The product of a thorough 10-year endeavor to catalog and map every tree stand in Maryland larger than five acres, Besley's *The Forests of Maryland* (1916) is regarded as the finest detailed forest survey to come out of the World War I period. Besley later recalled, "I'd hire a horse and buggy at a livery stable and jolt out along the dirt roads as far as possible and then on foot follow the cow paths up through the woods until I tramped over every woodlot above five acres in every county." The map below indicates the detailed work that went into *The Forests of Maryland*. (University of Maryland, Baltimore.)

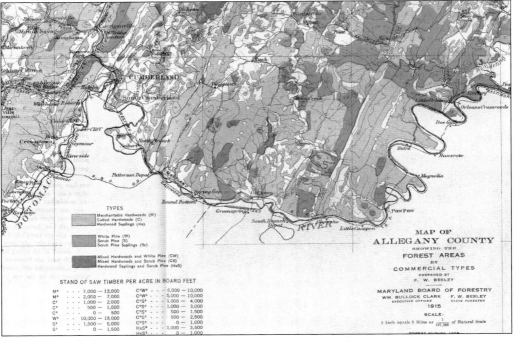

TYPES

Merchantable Hardwoods (M)
Culled Hardwoods (C)
Hardwood Saplings (Hs)

White Pine (W)
Scrub Pine (S)
Scrub Pine Saplings (Ss)

Mixed Hardwoods and White Pine (CW)
Mixed Hardwoods and Scrub Pine (CS)
Hardwood Saplings and Scrub Pine (HsS)

MAP OF
ALLEGANY COUNTY
SHOWING THE
FOREST AREAS
BY
COMMERCIAL TYPES
PREPARED BY
F. W. BESLEY

MARYLAND BOARD OF FORESTRY
WM. BULLOCK CLARK F. W. BESLEY
 EXECUTIVE OFFICER STATE FORESTER

1915

SCALE:
1 inch equals 3 Miles or $\frac{1}{187,500}$ of Natural Scale

STAND OF SAW TIMBER PER ACRE IN BOARD FEET

M³	· · · 7,000 — 12,000	C⁴W²	· · · 6,000 — 10,000
M²	· · · 2,000 — 7,000	C⁴W²	· · · 5,000 — 10,000
C¹	· · · 1,000 — 2,000	C⁴S²	· · · 1,000 — 4,000
C²	· · · 500 — 1,000	C⁴S²	· · · 1,000 — 3,000
C³	· · · 0 — 500	C²S²	· · · 500 — 1,500
W⁵	· · · 10,000 — 18,000	C²S²	· · · 500 — 2,500
S¹	· · · 1,500 — 5,000	C²S²	· · · 0 — 1,000
S²	· · · 0 — 1,500	HsS²	· · · 1,000 — 2,500
		HsS⁴	· · · 0 — 1,000

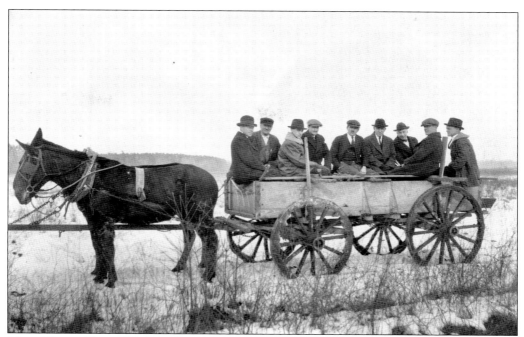

MULE WAGON TOUR. While Besley reached out to the general public to promote forest conservation, in particular, he sought out local residents and politicians. On February 9, 1923, local county agents and farmers pause for a photograph as they surveyed forestland near Holloway in Cecil County. (MSA.)

TREE-PLANTING CREW. A tree-planting crew takes a rest in Garrett County in April 1922. Until the development of the mechanical tree planter 20 years later, most trees were planted the old-fashioned way—with shovels, picks, and sore backs. Given these obstacles, the number of trees planted under Besley's direction is staggering. It is work gangs like this that transformed Garrett County's abandoned farmland into the lush forests seen today. (DNR.)

LOBLOLLY PINE. On the Eastern Shore, Besley aggressively promoted the growing of loblolly pine. Several studies were conducted to demonstrate the tree's value. Landowners were encouraged to destroy all other trees, especially hardwoods, in favor of loblolly pine. Found throughout the Southeast, the tree, seen here in August 1919, remains highly valued in the lumber industry. It is often used to make paper, lumber, poles, piling, and plywood. (DNR.)

CHRISTMAS TREE VANDALS. Not all of Besley's challenges involved recalcitrant landowners, lumber companies, and forest fires. Here in October 1923, Besley has captured on film a family's clandestine effort to steal a Christmas tree. Despite Besley's best efforts to promote responsible, scientific forest management among the general public, old habits died hard. (DNR.)

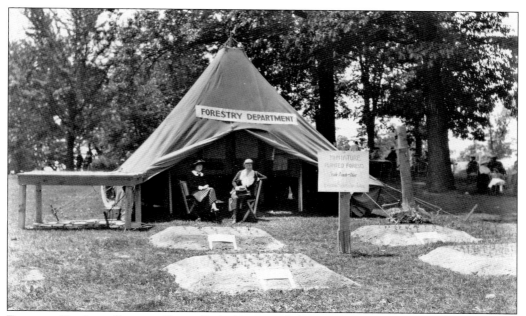

FARMERS DAY'S AT COLLEGE PARK. Besley's responsibilities included teaching forestry courses at the Maryland Agricultural College, which became part of the University of Maryland at College Park in 1921. Here two unidentified women staff a forestry display tent, complete with miniature planted forests, on May 26, 1923. That same year, the university's board of regents took control of the State Board of Forestry, renaming it the Maryland Department of Forestry. (MSA.)

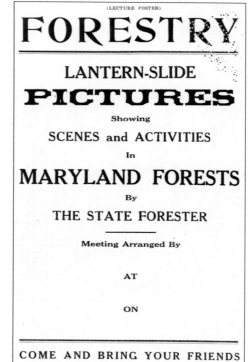

(LECTURE POSTER)

FORESTRY

LANTERN-SLIDE

PICTURES

Showing

SCENES and ACTIVITIES

In

MARYLAND FORESTS

By

THE STATE FORESTER

Meeting Arranged By

AT

ON

COME AND BRING YOUR FRIENDS

SLIDE PROGRAM ADVERTISEMENT. To promote forest conservation, Besley regularly traveled throughout the state to give lantern-slide presentations. The presentations often highlighted how individual landowners could better manage their forestland. In rural areas, Besley typically threw up a bed sheet on the side of a barn and powered a slide projector by jacking up the back of his car and attaching a belt to the axle. (DNR.)

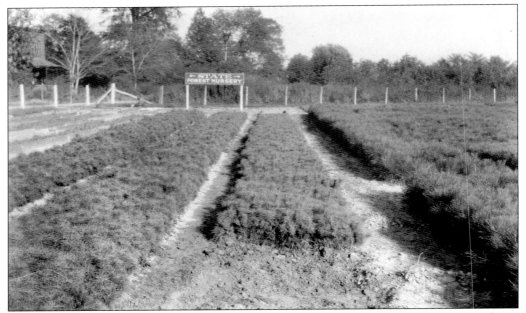

FORESTRY NURSERY. In 1914, the State Board of Forestry established the first state-owned tree nursery at College Park. Located along the banks of Paint Branch, the nursery operated until the mid-1950s. Seen here in October 1929 are rows of white pine seedlings. The nursery maintained a stock of nearly half a million trees by 1925. Most of the nursery crop ended up in the state forests and parks or beautifying Maryland's roadsides. (DNR.)

SILAS SINES. Silas, the nephew of resident warden Abraham Lincoln Sines, was initially reluctant to leave his native Garrett County and move to College Park to oversee the state tree nursery. After three persuasive letters from Besley, Silas agreed to relocate. He ultimately served as head of the nursery for almost half a century from 1929 to 1974. Silas took great pride in working in the field. Here he shows off pine seedlings in the early 1930s. (Silas Sines Jr.)

SEPARATING PINE SEEDLINGS. A nursery worker separates pine seeds from pinecones in December 1924. (DNR.)

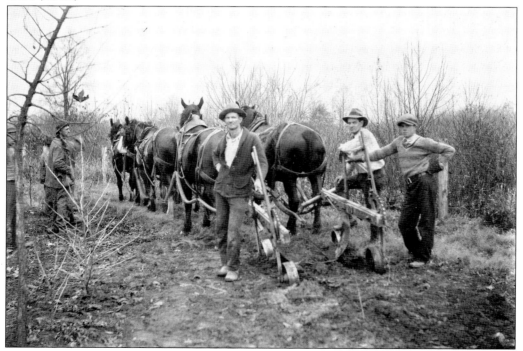

TREE DIGGER. The nursery crew, including Silas Sines (second from the right), pauses for a picture in November 1929. (MSA.)

BALTIMORE-WASHINGTON BOULEVARD. A busy route complete with strip malls today, U.S. Route 1 in College Park was decidedly rural when Besley snapped this shot in May 1921. So quiet was the road during this period that nursery workers used to play horseshoes in the road during breaks, removing the stakes whenever an automobile interrupted the tranquility. (DNR.)

ROADSIDE TREES. Besley's agency enforced the nation's first roadside tree law. Intended to beautify Maryland's highways by encouraging utility companies and the State Roads Commission to plant and maintain roadside trees, this 1914 law served as a model across the nation. New roadside trees were planted and raised in the state nursery in College Park. Here recently planted ash trees line the streets of Mount Rainier in May 1930. (MSA.)

NORWAY MAPLES NEAR LAUREL. Today's ecologists would be alarmed by some early forestry practices. Here along Washington Boulevard (present-day U.S. Route 1) in October 1921, the local forest warden has trimmed a crop of Norway maples. Valued for their appearance, Norway maples were widely planted as ornamental shade trees. The state nursery even maintained a crop. Norway maples are now considered pesky weed trees that out-compete native plants. (DNR.)

CONCRETE-ENCASED TREES. When it came to saving trees, no effort was spared. In June 1928, the State Roads Commission has encased the base of two large trees in concrete to protect them after Philadelphia Road was widened and leveled. The State Board of Forestry worked closely with the State Roads Commission and local utilities to protect roadside trees. (DNR.)

ILLEGAL ROADSIDE ADVERTISEMENT. The 1914 roadside tree legislation also called for the prohibition of unauthorized commercial advertising on public highways. For recreation on some Sunday afternoons, Besley took his family out, armed with handsaws, to cut down commercial signs that violated the law. Besley would need more than handsaws, however, to take down this advertisement in Rockville in June 1921. (DNR.)

RITCHIE HIGHWAY. Generally Besley maintained positive relations with the State Roads Commission; however, he sometimes marveled at their lack of taste. In this particular picture dated June 1939, Besley lamented over "what might have been" (written on the back of the picture) by pointing out the lonesome clump of trees in the distance in an otherwise treeless highway median. (DNR.)

CHAMPION TREE. In 1925, Besley organized the nation's first Big Tree Champion Program—a contest to find, note, and photograph the largest trees in Maryland. Ultimately the forestry department published *Big Tree Champions of Maryland* in 1937. Up-to-date publications followed in 1956, 1973, and 1990. Pictured here in September 1931 is William Walters' prized sassafras near La Plata. Normally an understory tree, this sassafras measured 64 feet in height. (DNR.)

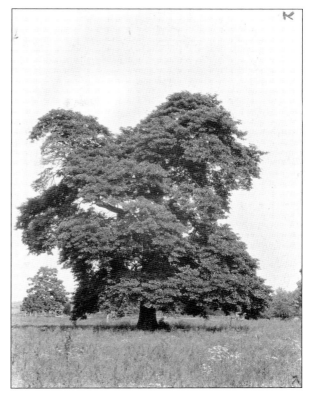

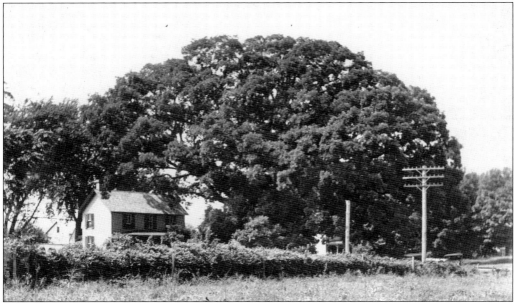

WYE OAK. By far the most recognized champion tree, Besley first examined the Wye Oak at Wye Mills in 1909. Estimated to have first sprouted in 1540, the majestic white oak was 96 feet high with a crown spread of 119 feet, covering nearly a third of an acre. The tree became a state park in 1939. Two decades earlier, Besley captured this view in August 1920. (DNR.)

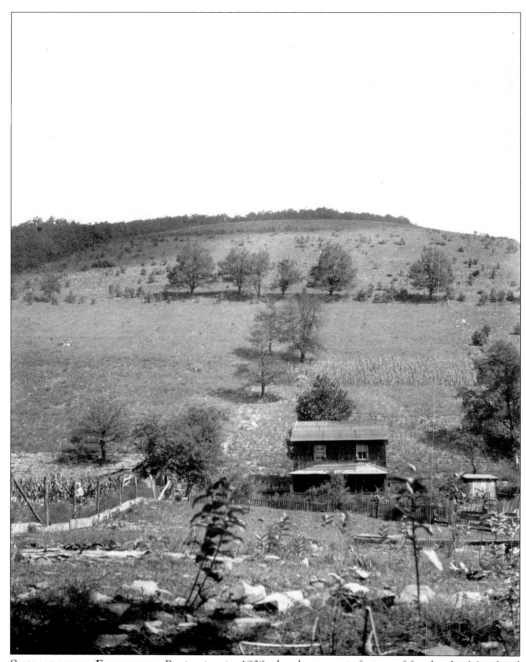

SUBMARGINAL FARMLAND. Beginning in 1929, thanks to an infusion of funds, the Maryland Department of Forestry began to purchase vast tracts of farmland classified as "submarginal." The vast majority of this land was located in Western Maryland, such as this tract along Elk Lick in Garrett County. Within a few years, the department controlled over 49,000 acres, thus laying the foundation for today's forest and park system. (DNR.)

Three

OUTDOOR RECREATION
Maryland's Earliest State Parks

From the start, state forester F. W. Besley emphasized forest conservation as his agency's primary goal—all other goals were secondary. Nevertheless, tight budgetary appropriations forced Besley to broaden the State Board of Forestry's appeal and purpose. Besley soon seized upon a passage tucked in the 1906 Forestry Law: a stipulation calling for "the protection and improvement of State parks." By having the state forest reserves double as public parks, Besley believed he could enlarge his agency's budget and educate more people about forest conservation.

There was a demand for outdoor parks—especially in Baltimore City, where civic leaders had been struggling to develop a park system since the late 19th century. A growing middle class increasingly removed from the outdoors sought to "get back to nature" by spending free time engaging in intense exercise and by visiting natural settings. Public parks met these demands. By developing state forest reserves as parks, Besley concluded, he could complement the city's park system and, more importantly, increase his budgetary appropriations.

In 1912, Besley asked the Maryland General Assembly to provide funds necessary to enlarge the Patapsco Reserve, a 43-acre plot in Baltimore County. He wrote, "The Patapsco Reserve is located only a few miles from Baltimore in a picturesque region, where it can best serve as a State park for recreation and pleasure. It is the desire of the Board to increase the area of the reserve and to develop it along park lines, provided the needed appropriation to purchase additional lands may be secured."

Besley put together a powerful alliance of urban elites and civic leaders and successfully lobbied the state legislature to increase his agency's funding. The State Board of Forestry's annual operating budget more than doubled in 1913, and it received funds to purchase Patapsco Valley property and complete various other stalled projects—most notably, the publication of Besley's *The Forests of Maryland*. The assembly also provided funds to purchase the remains of historic Fort Frederick, though the fort remained in private hands for another decade.

CARVILLE D. BENSON. As speaker of the house of delegates, Benson helped push through the Forestry Act of 1906. Six years later, as a member of the state senate, he introduced legislation to expand the Patapsco Forest Reserve. The son of a real estate developer in nearby Halethorpe, Benson had an interest in transforming the forest reserve into a public park. In the early 20th century, parks were viewed as catalysts for suburban development. (EPFL.)

CAMPING ADVERTISEMENT. Though it would not officially be renamed Patapsco State Park until the 1930s, Besley and the State Board of Forestry began to informally refer to the Patapsco Forest Reserve as a park as early as 1911. (DNR.)

SPECIAL POSTERS FOR PATAPSCO RESERVE.

(Sign prepared and posted in co-operation with the Baltimore and Ohio Railroad.)

PATAPSCO PARK

STATE FOREST RESERVE

Attractive Camping Sites

NEAR HERE

FREE UPON APPLICATION

State Forester, Baltimore Forest Patrolman, Oella

Or Local Agent
Baltimore & Ohio R. R.

(Sign posted to conform with a recent ruling of the Board of Forestry.)

NO HUNTING!

FIREARMS PROHIBITED

PATAPSCO STATE PARK

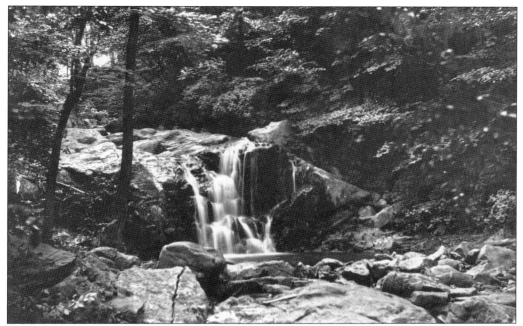

CASCADE FALLS. While it often takes a scavenger hunt to find remnants of Patapsco State Park's early days, this waterfall remains a constant. So attractive was the Cascade Falls that many visitors opted to set up their camps nearby. Even Besley himself regularly camped with his family along the Cascade Branch, where they educated city people about roughing it in the outdoors. The Cascade Falls remains a popular attraction today. (EPFL.)

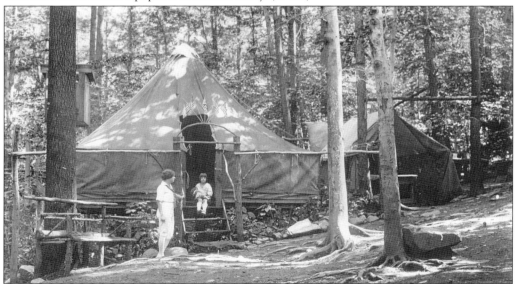

HAMILTON CAMP. Seeking to escape the Baltimore City heat, some visitors opted to spend the entire summer in Patapsco. Provided that they dug their own latrine and obeyed the strict fire laws, families could camp out free of charge. Here young Elaine Hamilton and her mother enjoy a respite. Growing up in the park contributed to Elaine's creativity and, by her own testimony as an adult, helped sharpen her skills as a professional artist. (Hamilton family.)

41

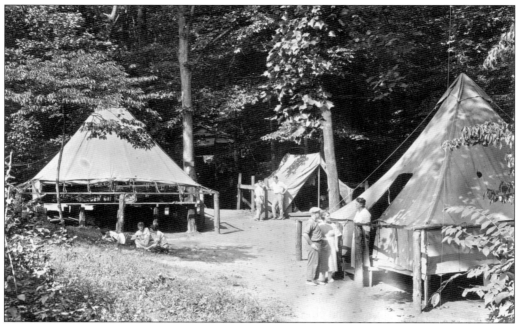

HUTZLER CAMP. To promote loyalty among its employees, the Hutzler department store in Baltimore reserved dozens of campsites each summer for their male employees—primarily sales clerks—and their families. While the men commuted daily to Baltimore, their families remained behind to enjoy the park. The company fostered camaraderie by reserving sites in close proximity to one another, operating a nearby commissary, and delivering ice cream once a week. (DNR.)

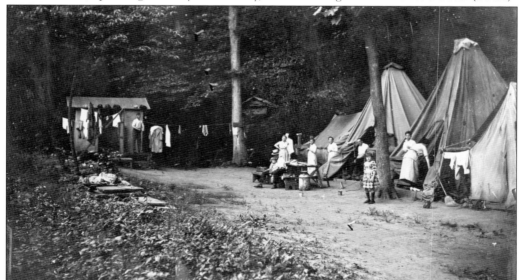

VINEYARD CAMP. Patapsco's campers typically stayed in World War I army tents—wooden platforms with wooden frames covered in canvas. Though the camps were somewhat ramshackle in appearance, campers rarely roughed it in the strictest sense. Many campers had electricity wired in for lighting and radios, and one family went so far as to bring their piano. Groceries and other necessities were purchased at the nearby mill town of Thistle. (DNR.)

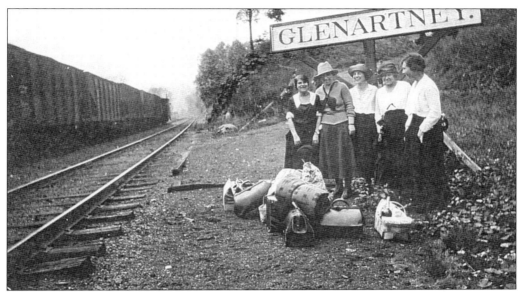

GLEN ARTNEY STATION. While some families opted to brave the primitive county roads, others opted to use the most modern and efficient means of transport in the early 20th century—the railroad. The B&O's Old Main Line passed through the Patapsco Valley near the reserve, and it maintained stops at Avalon, Glen Artney, Vineyard, Orange Grove, and Ilchester. (DNR.)

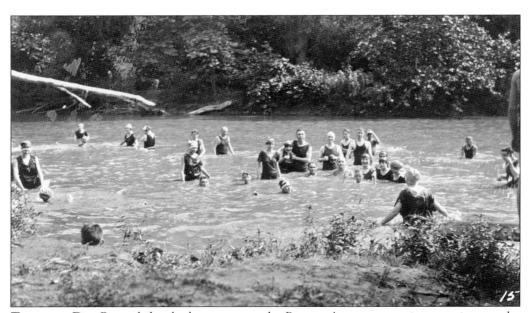

TAKING A DIP. Beyond the shady tree cover, the Patapsco's most attractive amenity was the river itself. Campers and daily-use picnickers often swam in the chilly river to escape the summer heat. (MSA.)

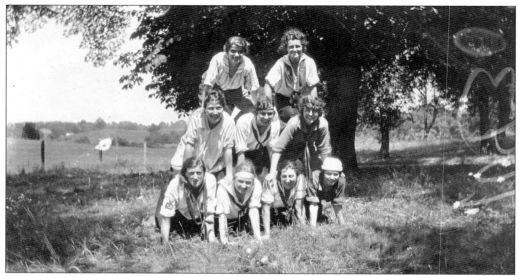

WORKING TOGETHER. Besley encouraged youth groups such as the Boy Scouts of America and the Young Women's Christian Association (YWCA) to camp in the Patapsco Reserve. In the early 1920s, nine members of the YWCA carefully pose for the camera. (DNR.)

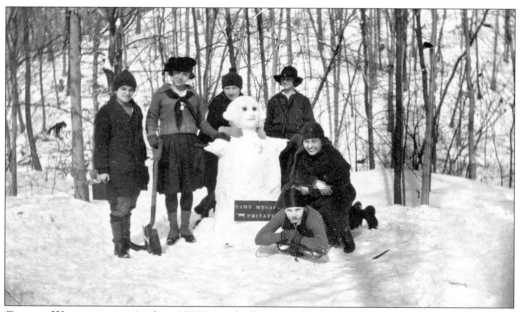

GEORGE WASHINGTON. As these YWCA girls illustrate, the Patapsco Reserve was not quiet during the winter months. Showing off their artistic talent, the YWCA girls have elicited the help of a famous American hero to point the way toward their winter camp in the early 1920s. (MSA.)

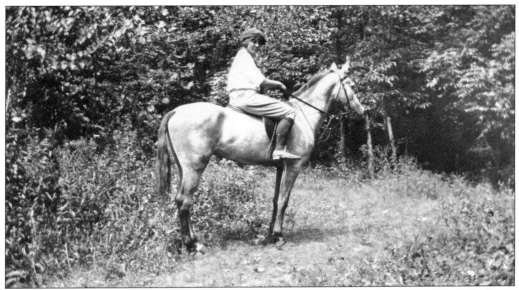

HORSEBACK RIDING. Riding is still a popular activity in Patapsco today. A YWCA girl takes a ride on horseback in the early 1920s. (DNR.)

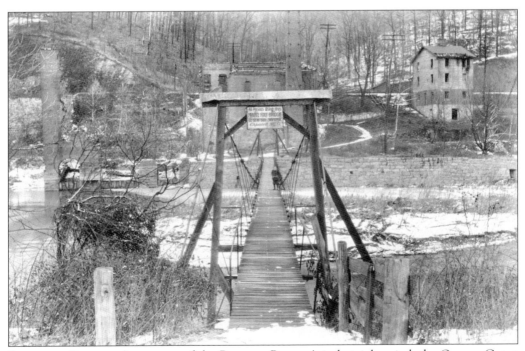

SWINGING BRIDGE. A remnant of the Patapsco Reserve's industrial period, the Orange Grove Swinging Bridge once allowed mill workers to get back and forth from work and home. After the flourmill burned in 1905, the bridge became a popular means for park visitors to cross the river. Due to fire and floods, the bridge has gone through several incarnations but remains in use today. This is how it appeared on March 7, 1920. (MSA.)

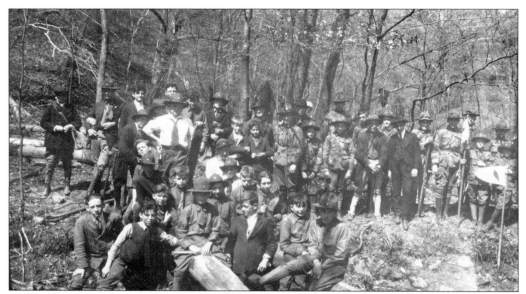

BOY SCOUTS. Robert Garrett is often credited for bringing the Boy Scouts of America to Baltimore. Besley often solicited their help to build various improvement projects, such as footbridges and small shelters. On one occasion, Boy Scouts even provided food for visiting dignitaries. On April 23, 1920, a Scout troop poses for the camera before they begin work on a bridge and cabin in Patapsco Reserve. (DNR.)

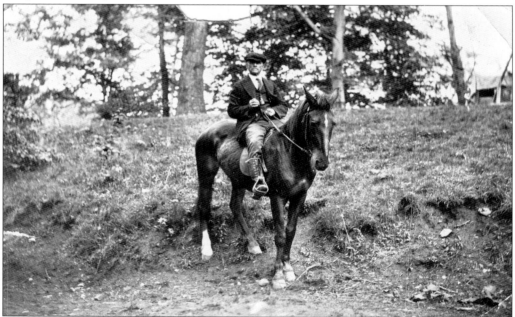

EDMUND GEORGE PRINCE. Patapsco Reserve's forest wardens were jacks-of-all-trades. In addition to watching for and preventing forest fires, wardens were also charged with protecting park visitors and campers. Forest wardens also depended heavily on family support. Wives and children often assisted forest wardens in tending to their duties—a 24-hour-a-day affair. E. G. Prince served as Patapsco Reserve's chief warden for three decades and was succeeded by his son David. (Ed Whyte.)

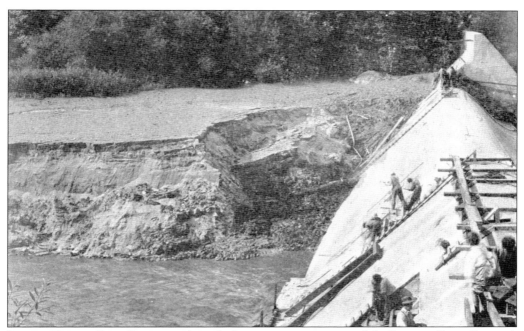

BEHIND BLOEDE DAM. Businesses that relied on waterpower supported the Patapsco Forest Reserve's expansion. Here in 1916 at Ilchester, the Consolidated Gas and Electric Company of Baltimore has drained the lake behind its hydroelectric dam to clear away silt and sediment. Because the dam's intakes were located underwater, sediment build-up was a persistent nuisance. A healthy forest buffer along the riverbank helped alleviate this problem. (DNR.)

LAND CLEARED FOR SUBURBAN DEVELOPMENT. In the heart of what is now Catonsville, Besley's camera captured this open field in 1920. The same impulses that enticed Baltimoreans to escape the city heat by visiting the Patapsco Reserve for a day's respite also drove them to seek homes in this formerly rural region of Baltimore County. (DNR.)

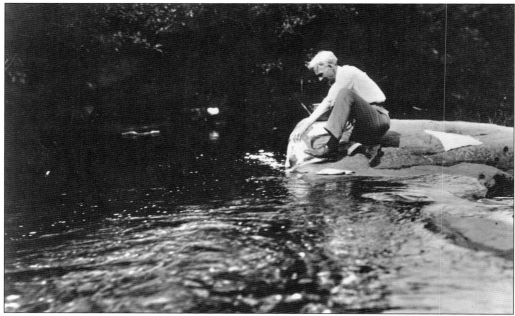

HENRY FORD AT MUDDY CREEK FALLS. Despite clear-cut lumbering and forest fires, some areas of Western Maryland remained pristine. So attractive were the picturesque waterfalls and hemlock forests of Swallow Falls that some of the most famous men in America could sometimes be seen auto-camping nearby. In the early 20th century, Henry Ford washes his clothes near Muddy Creek Falls in Garrett County. (GCHS.)

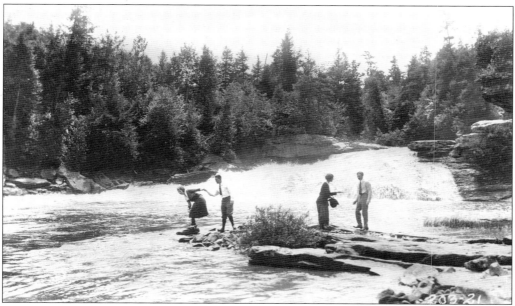

HENRY FORD PARTY. Two unidentified members of Henry Ford's camp converse at Swallow Falls while two others venture out to the Youghiogheny River's edge. Swallow Falls was named for the swallows that used to inhabit the cliff walls overlooking the river. This area is so popular today that swallows rarely nest here. (GCHS.)

MUDDY CREEK FALLS. One of the most beautiful spots in Maryland, Muddy Creek Falls is the state's highest free-falling waterfall, measuring 53 feet in height. Its 300-million-year-old shale and siltstone date to the Pennsylvanian period, and the surrounding hemlock forest has never been logged. In a rare pre-1920 photograph, Besley's camera captured this view of Muddy Creek Falls in August 1918. (DNR.)

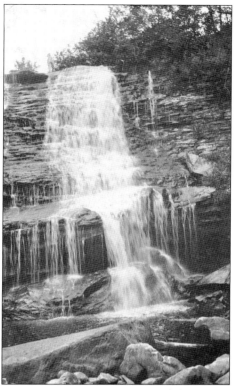

CAMPING AT SWALLOW FALLS. Ordinary people also made the trek out to Garrett County to see the falls. Here an unidentified woman rests on a picnic table in August 1931. (DNR.)

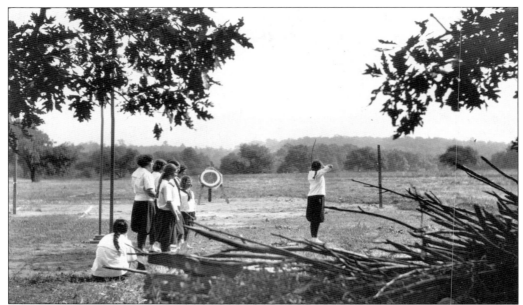

ARCHERY AT CAMP ROBIN HOOD. Like Patapsco Reserve, Besley promoted Western Maryland forests as recreation areas, though their distance from population centers initially limited their appeal. In August 1921, an unidentified Camp Robin Hood girl takes aim while her campmates watch. (MSA.)

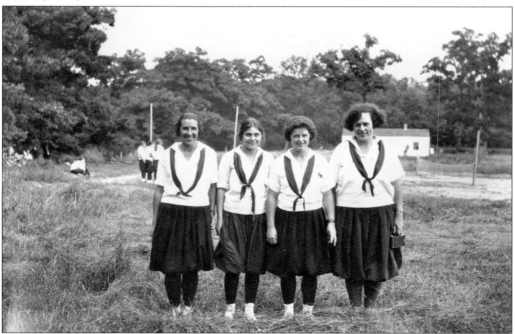

CAMP ROBIN HOOD COUNSELORS. Today Herrington Manor is known for its lake and full-service cabins. In the 1920s, however, Herrington Manor featured only a few primitive campsites and athletic fields. Camp Robin Hood counselors had few complaints as they posed at Herrington Manor in August 1921. (MSA.)

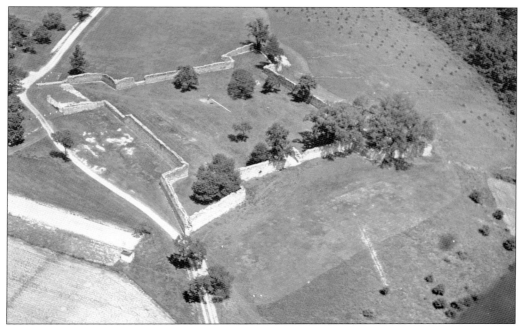

FORT FREDERICK. The State Board of Forestry also had an interest in historic preservation. Built in 1756 during the French and Indian War, Fort Frederick was the first stone-built fort on the British Colonial frontier. State senator William McCulloh Brown took a special interest in its preservation. The board initially received funds necessary to purchase the fort in 1912, but a dispute with the landowner forced it to wait until 1922. (DNR.)

DAR FOREST. To justify the State Board of Forestry's acquisition of Fort Frederick, Besley worked closely with the Daughters of the American Revolution (DAR) to plant a forest adjacent to the fort in 1926. Ironically the trees were not consistent with the fort's historic character. Colonial forts were typically built in open fields for better visibility. Nevertheless, the DAR forest survived into the 1990s, when it was harvested for lumber—its original purpose fulfilled. (DNR.)

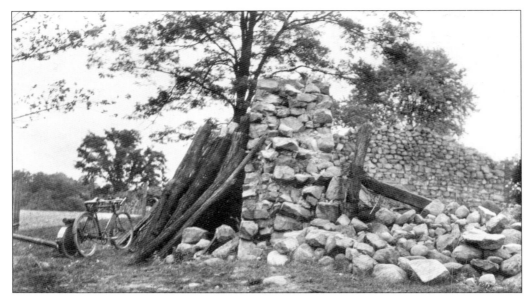

PILFERED STONES. A magnificent sight in its glory years, Fort Frederick's stone walls had significantly deteriorated by the early 20th century. As this May 1921 photograph of the northwest bastion indicates, farmers have raided the walls for stone. While the State Board of Forestry immediately put a stop to the stone pilfering and promoted the fort as a tourist attraction, restoration of the fort's walls would have to wait until the 1930s. (DNR.)

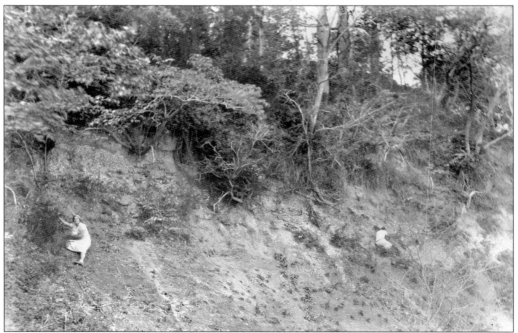

FOSSIL HUNTING. Long before Calvert Cliffs on the Chesapeake's southwestern shore became part of the state forest and park system in 1966, people regularly picked for prehistoric fossils in the cliff's red sandstone. Here an unidentified man and woman precariously cling to the hillside in September 1934. (DNR.)

Four

THE CIVILIAN CONSERVATION CORPS

Modernizing Maryland's Forests and Parks

The greatest economic disaster of the 20th century resulted in the first nationwide effort to improve public parks and forests. To rescue America from the Great Depression, Pres. Franklin D. Roosevelt's administration developed a series of public works programs to put Americans back to work. Most notable among these programs was the Civilian Conservation Corps (CCC), which operated from 1933 to 1942. The CCC established over 60 camps in Maryland and put over 30,000 young men to work across the state.

As federal money and labor poured into Maryland, state forester F. W. Besley found himself coordinating massive building projects on a scale he could have scarcely dreamed of before. According to Besley, the CCC advanced Maryland forest and park development by 25 years. The CCC provided the Maryland Department of Forestry with its first modern infrastructure at parks such as Elk Neck, Gambrill, Herrington Manor, New Germany, Pocomoke (Milburn Landing), and Patapsco. These improvements included drinking water, restrooms, pavilions, cabins, lakes, and campgrounds. The department also partially restored historic Fort Frederick and acquired other historic sites, including the Washington Monument and the Wye Oak. New roads and highways made these new parks accessible to the general public, and park attendance rose during the late 1930s and early 1940s. Moreover, the department acquired new forests, and several established forests were expanded. The CCC also blazed new access roads and built new fire towers to assist in fire prevention. Though the department was often forced to find creative solutions to maintain the reserves and fight fires, the infrastructure built by the CCC proved invaluable to the state forests.

In the end, however, the New Deal's blessings proved to be mixed. The CCC camps were disbanded shortly after the nation entered the Second World War, and with their departure, the staff necessary to maintain the new infrastructure disappeared. The new and larger forests required management and fire protection techniques on a grander scale. The improved park facilities required more maintenance and staff. Meeting these new challenges would prove difficult—and, one could argue, these challenges have persisted ever since.

UNEMPLOYMENT RELIEF. Even before the formation of the CCC in 1933, the Maryland Department of Forestry put unemployed men to work. In December 1932, unemployed men take a lunch break while doing conservation work at the Patapsco Forest Reserve. (DNR.)

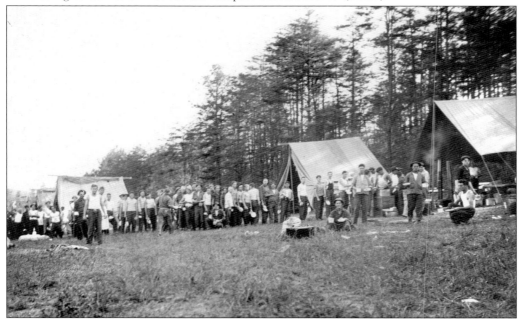

MEAL TENT. When the CCC boys first arrived at a camp, they were forced to live in improvised army tents until they had built their barracks. In May 1933, CCC boys at Green Ridge State Forest wait in line outside the meal tent while a few punctual members prepare to eat. Many of the CCC boys came from impoverished urban areas, where decent meals were a luxury. (DNR.)

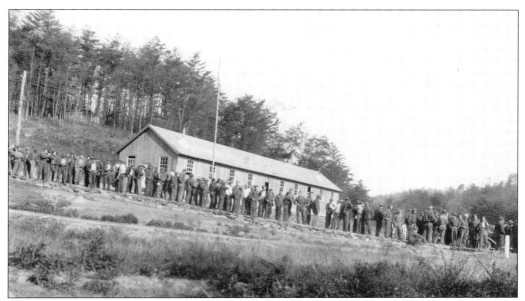

LINED UP FOR WORK. The CCC was a joint venture; the Labor Department recruited members, the Department of the Interior and/or Agriculture (in conjunction with state agencies) located conservation projects, and the War Department operated the camps. While discipline was not heavy handed, CCC boys were expected to be punctual and work hard. Here the boys line up for a day's work at Green Ridge in May 1934. (DNR.)

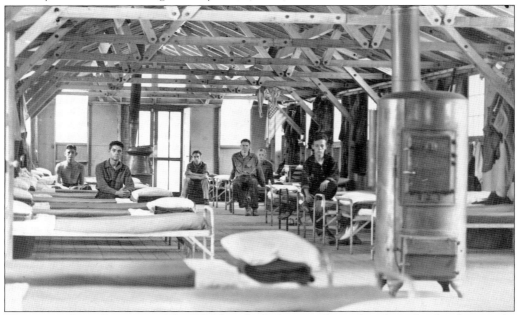

WESTOVER CAMP BARRACKS. The CCC boys built their own barracks, where they lived spartanly. Most CCC members were between the ages of 18 and 24, though in later years, 17-year-olds were enlisted. They earned $30 a month and were provided three meals daily. To ensure that the boys did not spend their money frivolously, all but $5 of their monthly salary was sent home to their families. (EPFL.)

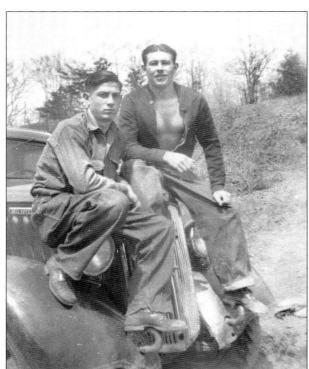

BREAK TIME. Despite only having $5 a month to spend, the CCC boys still found time to get out and recreate. Steve Peery (left) and Harry Sterling pose on an REO Speedwagon at Patapsco on April 3, 1937. Close proximity to Ellicott City and Baltimore provided the boys at Patapsco plenty of opportunities to find entertainment. (DNR.)

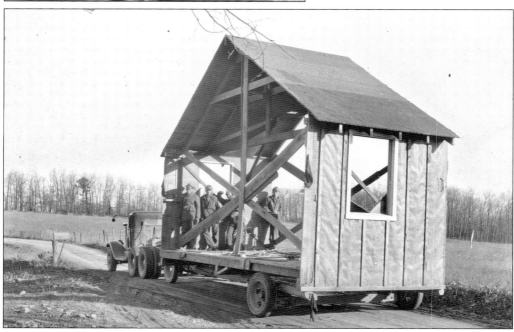

TRANSPORTING A BARRACK SECTIONAL. While the CCC had to build their own barracks, they did make them modular and (relatively) easy to move. Some camps moved regularly and were forced to bring their barracks with them. In January 1938, campers move a section of their barracks from Green Ridge to an unknown location. (DNR.)

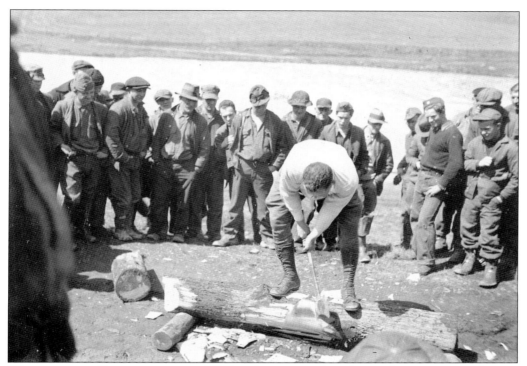

WOODCUTTING DEMONSTRATION. CCC workers received professional instruction on how to safely conduct their duties. In April 1934, a Mr. Christ of the Kelley Axe Company demonstrates how to safely and efficiently cut a log at New Germany. (MSA.)

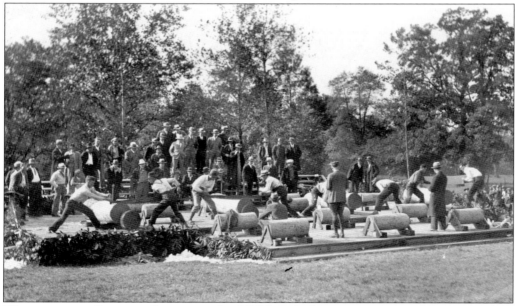

WOODCUTTING CONTEST. Sometimes the CCC boys had an opportunity to demonstrate their skills in a competition. On an unspecified date, CCC boys from different camps show off their woodcutting skills at a contest in West Virginia. (DNR.)

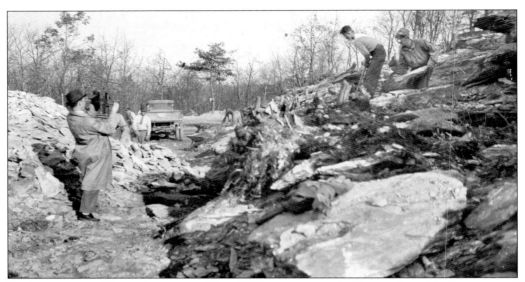

POSING FOR THE NEWS AMERICAN. The CCC proved remarkably popular with the press and regularly received positive coverage. Avery McBee of the *Baltimore Sun* wrote on February 10, 1935, "Its forestry work has been praised, but its social aspects well may prove to have been of even greater value." Mr. Shipley of the Baltimore *News American* photographs CCC workers at Gambrill in October 1938. (DNR.)

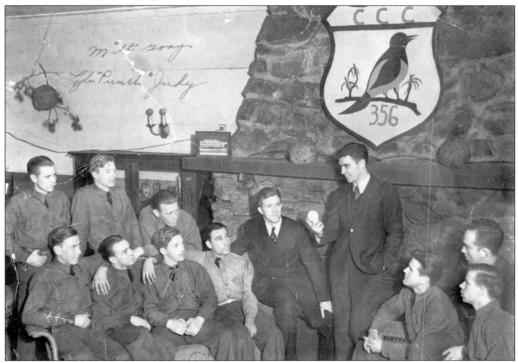

BALTIMORE ORIOLES VISIT CAMP. To keep morale high, celebrities and famous athletes were sometime recruited to speak at CCC camps. Among the athletes recruited to speak at Patapsco were Lyle "Punch" Judy and Milt Gray of the then-minor-league Baltimore Orioles. (DNR.)

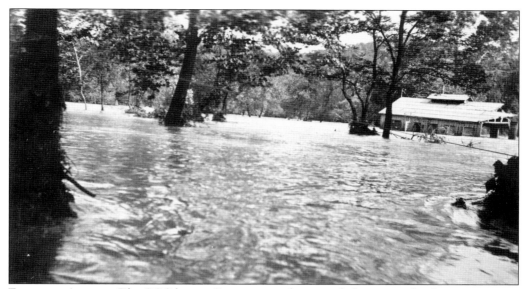

FLOOD AT AVALON. The CCC boys at Patapsco may have needed extra words of encouragement after a flood ripped through their tents in August 1933, only a few months after they had arrived. (DNR.)

REMOVING MATURE WHITE PINE. More famous for building park shelters and cabins, the CCC also conducted a lot of forestry work. This included fighting forest fires, blazing fire trails, planting trees, and, as is the case with these workers at Green Ridge in January 1937, the thinning of mature trees. (DNR.)

CUTTING TIMBER. Three CCC workers cut down a pine tree in Doncaster State Forest in Southern Maryland in July 1938. When it came to European Americans, the CCC made no distinction regarding ethnicity. It was common to find Jewish Americans serving in the same company with Italian Americans and Irish Americans. That same philosophy, however, did not apply to African Americans. Blacks were given the opportunity to serve in the CCC, but they served in segregated units. (DNR.)

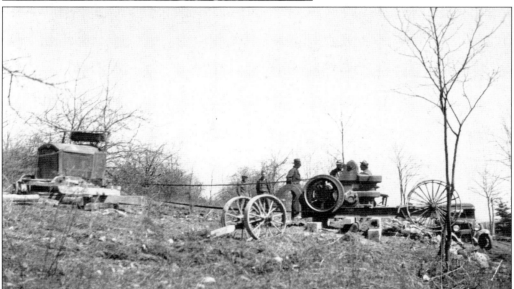

PORTABLE ROCK CRUSHER. Improvisation and making do with less was a necessity in the CCC. Perhaps nothing better illustrates this than the esoteric collection of spare parts assembled at Green Ridge in April 1934. For transport, the boys have attached a rock crusher to wooden farm wagon. For power, a belt has been attached to the remains of a Buick truck, complete with hood and windshield. (DNR.)

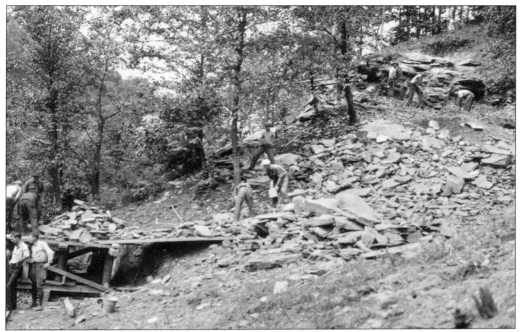

Quarrying Stone. Wherever possible, the CCC used local materials for their construction projects. At Savage River State Forest, workers break and load stones destined for Poplar Lick Road in September 1934. (DNR.)

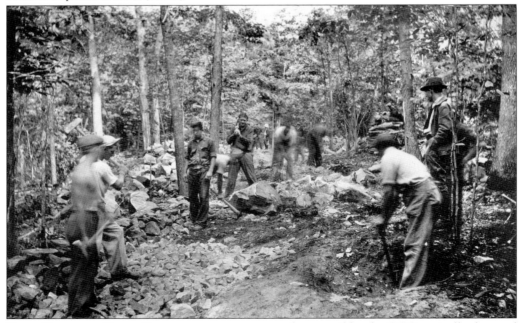

Road Building Crew. To put as many men to work as possible, the CCC typically shunned modern heavy machinery in favor of the axe, hammer, chisel, and wheelbarrow. In July 1933, CCC workers clear a road through Potomac State Forest the hard way, as one exhausted worker pauses for the camera. (DNR.)

HALFWAY THERE. CCC workers did utilize road graders and small dump trucks; beyond that, however, road construction was accomplished via sweat and muscle. A crew pauses to wait for more stone while building Poplar Lick Road in Savage River State Forest in August 1934. After the coarse layer of stone is completed, a finer layer of gravel will be applied to the top. (DNR.)

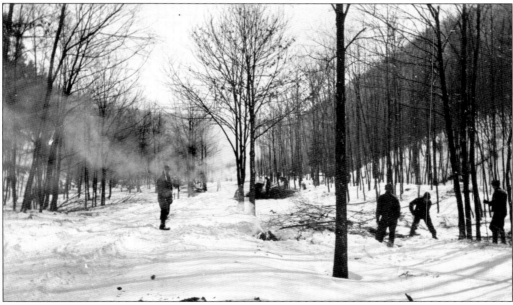

WORKING IN THE COLD. There was not much down time in the CCC. The boys worked year-round in all types of weather, even in the dead of the Garrett County winter. In December 1934, CCC workers make roadside improvements by clearing out underbrush along Big Run Road in Savage River State Forest. (DNR.)

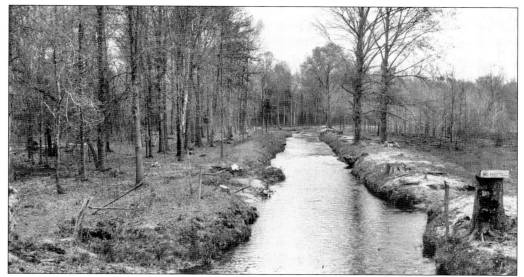

ZEKIAH SWAMP DRAINED. Historically wetlands were considered filthy swamps that harbored disease and waste. In the early 20th century, the only solution was to drain them and convert them into something deemed more useful—typically farmland. In the late 1930s, the CCC drained portions of Zekiah Swamp in southern Maryland. Today wetlands are considered valuable filters that help protect the Chesapeake Bay's fragile ecosystem. (MSA.)

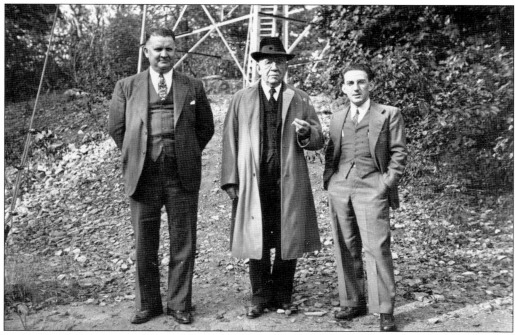

JAMES H. GAMBRILL JR. One of Frederick City's leading businessmen, "Uncle" Jim Gambrill (center) was a leader in Maryland's conservation efforts in the early 20th century. Cobbling together a powerful group of allies, he helped acquire over 1,000 acres of delicate watershed property near the city, including the overlook at High Knob. A portion of that land was later given to the Maryland Department of Forestry, forming Gambrill State Park. (MSA.)

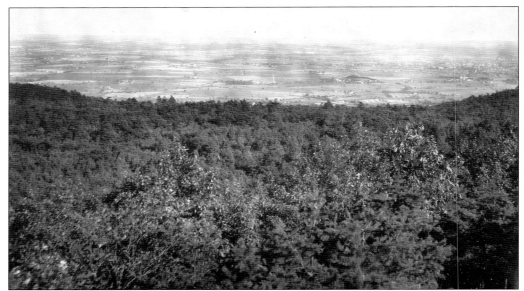

FREDERICK CITY OVERLOOK. In the 1890s, Jim Gambrill enjoyed buggy rides up to High Knob to take in the commanding views of the Middletown and Frederick City valleys. Forty years later, the CCC transformed this overlook into one of Maryland's most beautiful state parks. A rapidly developing suburb today, Frederick was a small town surrounded by farmland in October 1936. (DNR.)

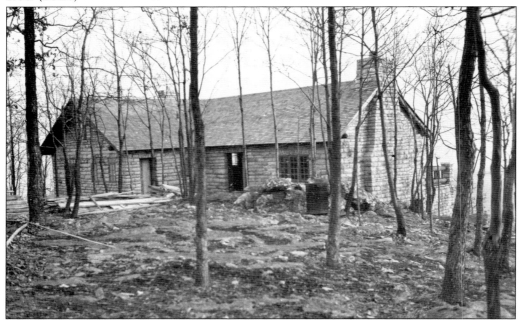

GAMBRILL TEA ROOM. The CCC constructed several stone overlooks and shelters at Gambrill State Park. The most notable structure, however, is the Tea Room. Seen here in December 1940, the Tea Room remains one of the park's most popular attractions. Built with local stone, it features a balcony that commands views of both the Middletown and Frederick City valleys, and its interior includes a kitchen, a dining room, and a large fireplace. (DNR.)

THE FIRST COMPLETED WASHINGTON MONUMENT. Though the Washington Monument in Baltimore was initiated first, this stone structure built near Boonsboro in 1827 was the first completed monument erected to honor George Washington. Unfortunately the monument was not consistently maintained, and it had to be rebuilt on several occasions. After several decades of neglect, the monument was once again in need of repairs in July 1931. (MSA.)

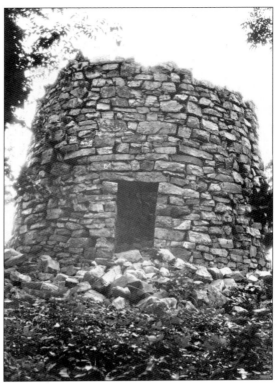

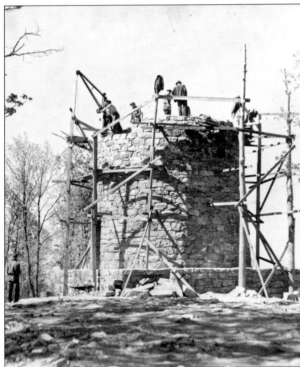

REBUILDING WASHINGTON MONUMENT. It was decided that CCC would be the last group to rebuild the monument. The CCC boys completely demolished and rebuilt it with the same stone, plus new concrete mortar. On June 10, 1935, a CCC boy carefully lifts a cement-filled wheelbarrow to the top while others evaluate their progress. (MSA.)

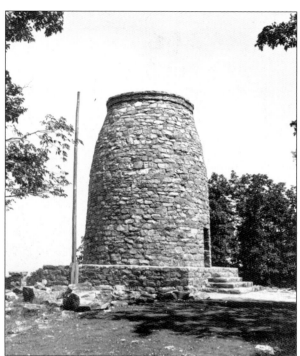

WASHINGTON MONUMENT COMPLETED. Restored to its former glory, the newly completed Washington Monument was rededicated on July 4, 1936. Located on South Mountain along the Appalachian Trail west of Frederick, the monument remains a popular tourist attraction today. (MSA.)

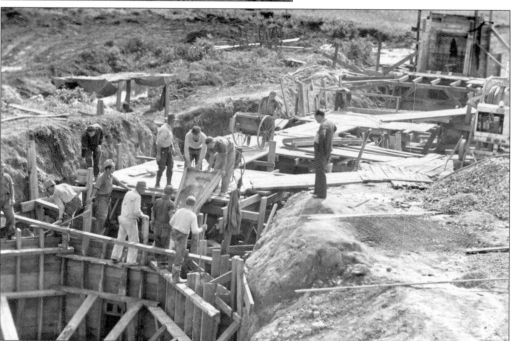

BUILDING HERRINGTON MANOR LAKE. Perhaps the most extensive park development effort took place at Herrington Manor, where a lake, bathhouse, and 16 full-service cabins were built. On October 6, 1936, a supervisor looks on as CCC workers pour concrete for the new dam at Herrington Manor. (MSA.)

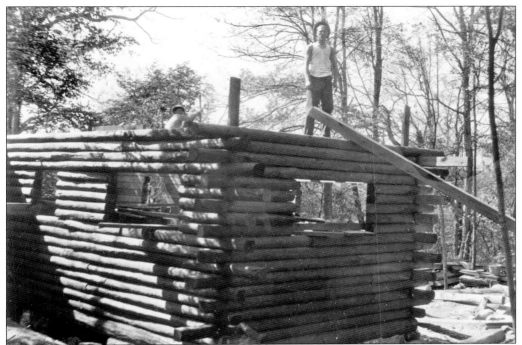

BUILDING CABINS AT HERRINGTON MANOR. Two CCC workers look up momentarily as they build a vacation cabin in the Herrington Manor Forest Recreation Area (now Herrington Manor State Park) in July 1938. Once finished, these cabins proved popular and are still used by vacationers year-round. (MSA.)

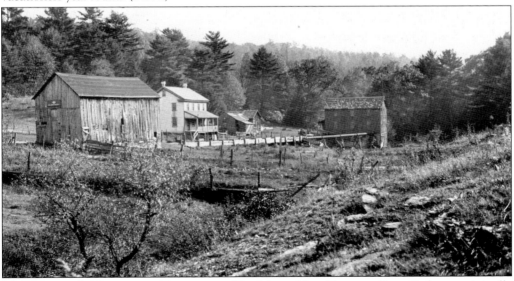

MACANDREW'S HOUSE AND FLOURMILL. The lake at New Germany State Park was originally built in the 19th century to provide power for a gristmill. The CCC obliterated all the structures visible in this October 1932 photograph and reconditioned the lake's dam. All that remains of the gristmill are its millstones, which are presently located at the entrance of a parking lot across from the dam. (DNR.)

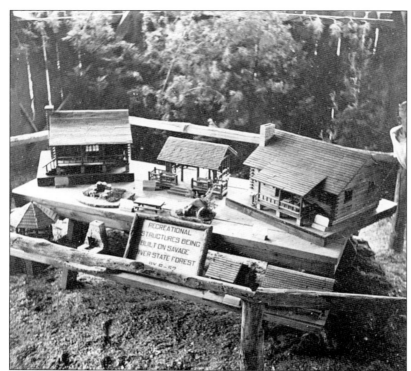

MODELS OF NEW GERMANY'S AMENITIES. To promote the new park facilities at New Germany, the CCC built several scale models of cabins, pavilions, and other structures. They soon made appearances at local community fairs such as Cumberland's sesquicentennial celebration in August 1937. (DNR.)

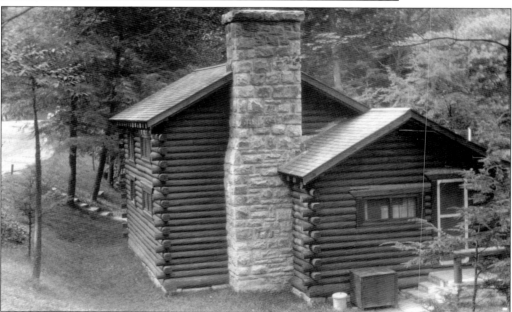

NEW GERMANY'S CABINS. The cabins in both New Germany and Herrington Manor were immediate hits with vacationers from Baltimore and Washington, D.C. Available year-round, these full-service cabins featured a fireplace, a kitchen, bathrooms, and several beds. Their scarcity, however, put them in high demand, and they were regularly booked, even during World War II. (DNR.)

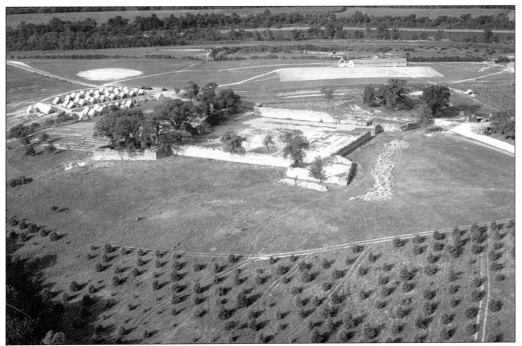

FORT FREDERICK. One of the more unique CCC projects was the restoration of Fort Frederick's stone walls. In August 1934, the CCC had built their mess hall (behind the fort) but had yet to build their barracks. The Williams' farmhouse, formerly occupied by an African American family that owned the fort prior to 1913, is still standing (to the right of the fort). (DNR.)

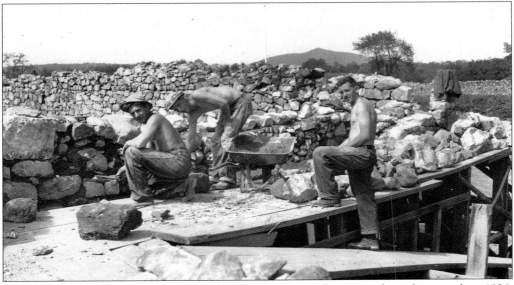

REBUILDING FORT FREDERICK'S WALLS. Shirtless CCC workers pause for a photograph in 1936. The heavy manual labor transformed many of the CCC workers into well-conditioned and fit young men, and during the summer months, they rarely shied away from showing off their new physiques. (MSA.)

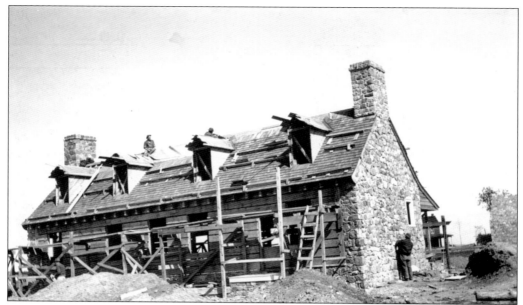

MUSEUM AT FORT FREDERICK. In the mid-1930s, the CCC boys constructed a combination administration and museum building south of the fort (which can be seen in the background on the right). Originally built to display artifacts found at the historic fort, this building now serves as a museum to the CCC. (DNR.)

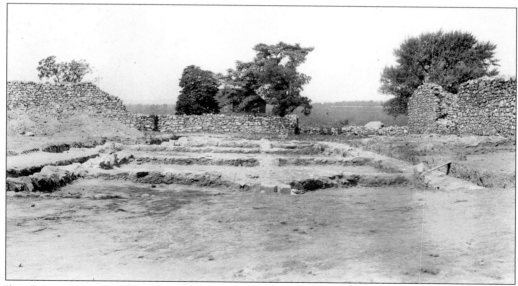

AN ARCHEOLOGIST'S NIGHTMARE. While the CCC is rightfully praised, not everything they touched turned to gold. In an effort to keep the boys busy, CCC administrators often initiated projects before consulting experts. As this photograph indicates, the CCC effectively ruined Fort Frederick's archeological value by digging up the grounds without carefully cataloging where artifacts had been found. (MSA.)

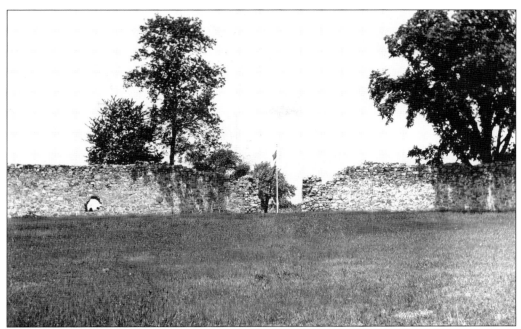

FORT FREDERICK BEFORE AND AFTER. The results of the CCC boys' rebuilding efforts are clearly illustrated by these two views of Fort Frederick's front gate. (DNR.)

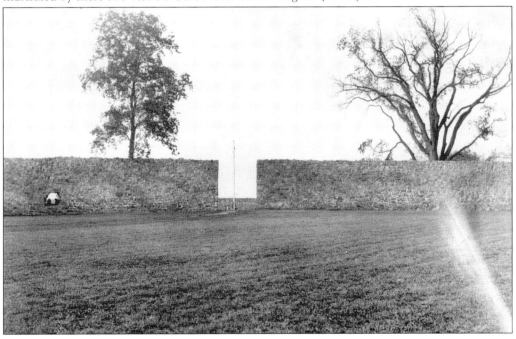

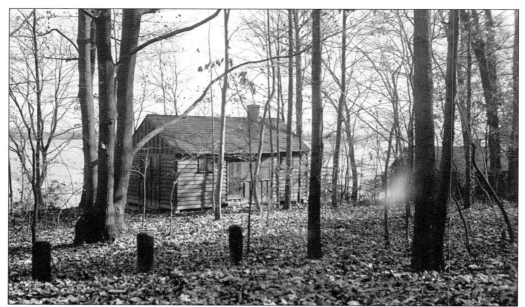

ELK NECK. Not all CCC park-building projects were in central and western Maryland. Near the mouth of the Susquehanna River, nine small cabins were built at Elk Neck State Park between 1937 and 1939. Besley hoped "to make it one of the finest parks in the state"; however, park development efforts at Elk Neck moved slowly, as recalcitrant neighbors refused to sell their land to accommodate park expansion. (DNR.)

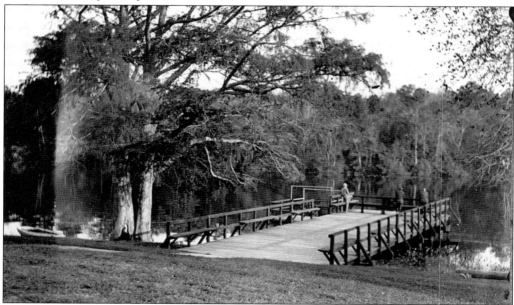

MILBURN LANDING. Most CCC projects on the Eastern Shore consisted of conservation work; however, they did build a concession building, two pavilions, a campground, and a fishing pier at Milburn Landing, now part of Pocomoke State Park. In October 1938, three unidentified people observe the Pocomoke River from the fishing pier. The pier stood until 2003, when a new pier was constructed in the same location. (MSA.)

Five

MID-20TH CENTURY
Balancing Conservation
and Recreation

In 1941, the Maryland Department of Forestry was renamed the Maryland Department of Forests and Parks, formally putting parks on equal footing with forestry. One year later, longtime state forester F. W. Besley retired. His successor, Joseph F. Kaylor, built on Besley's Depression-era accomplishments and helped establish 20 new state parks over the next two decades.

Post–World War II prosperity brought an even larger demand for park facilities. Between 1947 and 1967, Governors William Preston Lane Jr., Theodore R. McKeldin, and J. Millard Tawes aggressively promoted highway development. Increased mobility and leisure time (combined with a growing population) caused Maryland forest and park attendance to soar from 240,000 in 1945 to over 5.3 million by 1959. The state government responded by providing the Maryland Department of Forests and Parks with generous funds for park acquisition and development. Among the new parks acquired by the mid-1960s were Sandy Point, Cunningham Falls, Gathland, Deep Creek Lake, and Greenbrier. Meanwhile, established parks such as Herrington Manor received new facilities to complement their Depression-era accommodations. An effort to protect stream valleys from pollution and suburban development led to an expansion of Patapsco State Park and the establishment of Gunpowder Falls, Patuxent River, Seneca Creek, and Susquehanna State Parks and the South Mountain Natural Resource Management Area.

In 1952, the State Planning Commission, in conjunction with the Maryland Department of Forests and Parks, published a plan calling for $11 million for park development. The plan emphasized the state's diverse topography and environments and called for new parks to be established in every part of the state. Typical of the period, the plan called for intensive recreational development centered on automobile access.

Meanwhile, the middle decades of the 20th century proved to be among the finest for professional forestry in Maryland. Forest fires, still relatively commonplace in the late 1930s, decreased dramatically by the mid-1950s. In 1943, the Forest Conservancy Districts Act established a series of regional forestry boards to provide more localized advice and knowledge about forestry. It also dramatically expanded the department's ability to enforce fire and timber-cutting regulations.

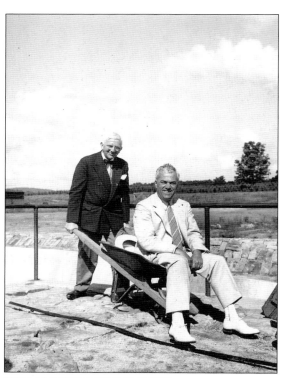

CURLEY BYRD AND WILLIAM P. COLE JR. Even though the University of Maryland Board of Regents took control of the State Department of Forestry in 1923, the regents allowed Besley to run his agency as he pleased. However, when H. C. "Curley" Byrd (sitting at Herrington Manor Dam) became university president in 1935, he attempted to have Besley and his assistant foresters reclassified as professors and moved from Baltimore to College Park. (DNR.)

BESLEY VERSUS BYRD. The *Baltimore Sun* took Besley's side in his dispute with Byrd and the University of Maryland regents, going so far as to mock Byrd in several political cartoons. In the face of strong political pressure, the state legislature restored the Department of Forestry's independence in 1940 by moving it (along with other state natural resource agencies) to a new Board of Natural Resources in Annapolis. (*Baltimore Sun.*)

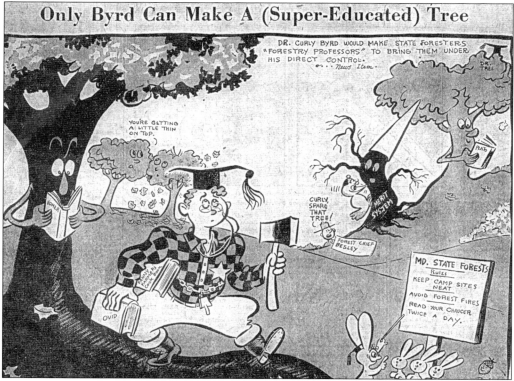

BESLEY AND RODGERS, INC. Besley believed it was unethical for him to personally own forestland while employed by the state. Retirement freed him from this self-imposed constraint. Beginning in 1942, Besley decided to practice in retirement what he had preached for decades by purchasing vast tracts of forestland on the Eastern Shore. Managed by the Besley and Rodgers Corporation today, this forest constitutes the largest private, non-industrial–owned forest in Maryland. (Besley-Rodgers family.)

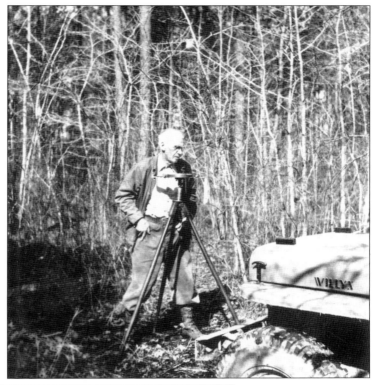

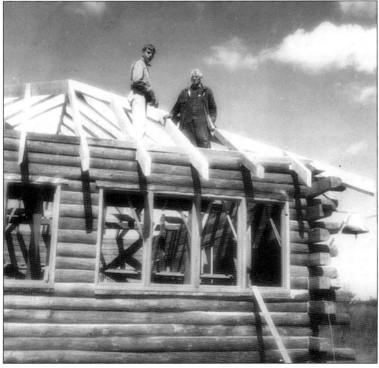

BESLEY AND GRANDSON. Besley's life after 1942 was as successful and event-filled as his tenure as state forester. In addition to establishing the Besley and Rodgers Corporation, Besley taught forestry courses at the University of West Virginia during World War II in place of his son Lowell, who was serving in the military. Here during the 1950s, Besley and his grandson Kirk Rodgers build a log cabin on the Eastern Shore. (Besley-Rodgers family.)

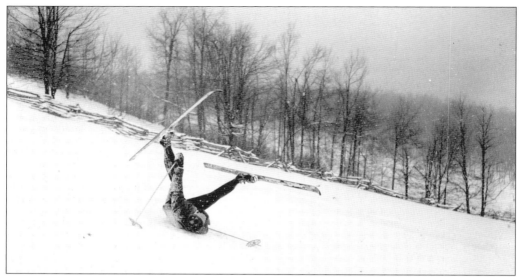

TUMBLING DOWN THE MOUNTAIN. New Germany featured one of the first public ski slopes south of the Mason-Dixon Line. Developed by Besley and district forester Henry C. Buckingham in the late 1930s, the ski slopes were a hit with tourists from Baltimore and Washington. Some patrons proved natural skiers; others needed practice. Here Charles Doherty skis the hard way on February 23, 1941. (DNR.)

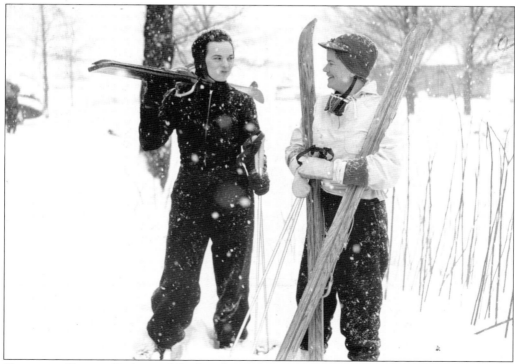

TAKING A BREAK. Besley and Buckingham encouraged women to visit New Germany's ski slopes. Here Maudeen Miller and Jessie Barnett pause and converse between runs on February 23, 1941. (MSA.)

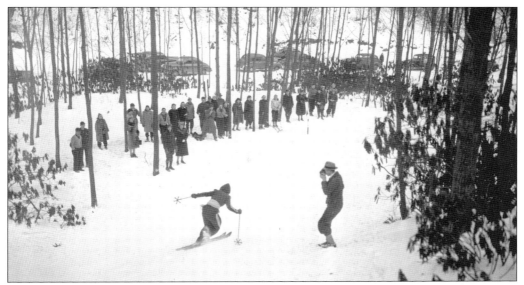

SKIING CONTEST. New Germany featured the first public skiing competition south of the Mason-Dixon Line in February 1941. (DNR.)

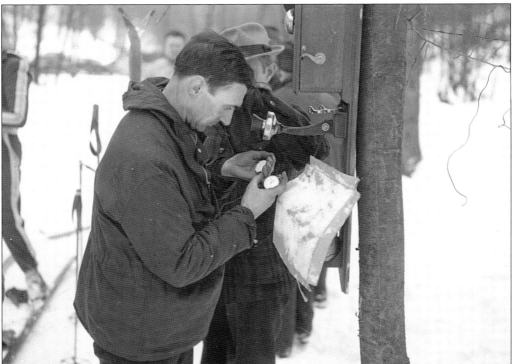

HENRY C. BUCKINGHAM. District forester Buckingham keeps time during a competition at New Germany in February 1941. Buckingham would go on to serve as Maryland state forester from 1947 to 1968. As state forester, he continued many of the programs initiated by Besley and took a strong interest in developing the state nursery at Harmans, which later was renamed in his honor. (MSA.)

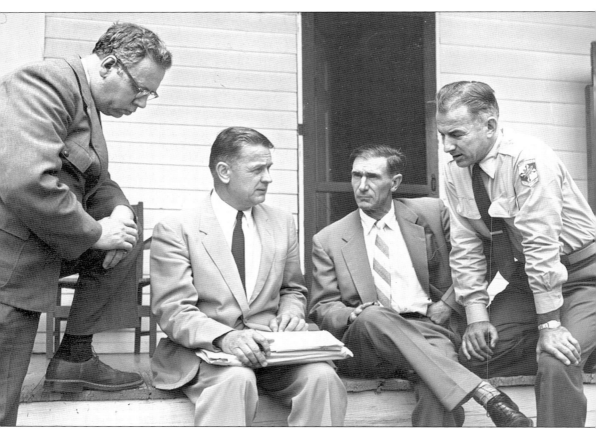

PARR, KAYLOR, BUCKINGHAM, AND BOND (FROM LEFT TO RIGHT). The Maryland Department of Forests and Parks had remarkably stable leadership during the mid-20th century. Bill Parr served as superintendent of state parks beginning in 1956 and was later the first director of the Maryland Park Service from 1972 to 1978. Department director Joe Kaylor put park acquisition high on his agenda and oversaw the attainment of over half of today's Maryland State Parks between 1942 and 1963. After retiring, Kaylor went on to serve on the Federal Bureau of Outdoor Recreation and worked to pass several of President Johnson's Great Society measures, most notably the Land and Water Conservation Fund Act of 1964. Henry Buckingham served as state forester during Kaylor's tenure and filled in for Kaylor on two occasions (see page 77). Adna R. "Pete" Bond served as an assistant state forester in the 1940s, later became chief of forest management in the 1960s, and was finally the first state forester of the Maryland Forest Service from 1972 to 1978. (DNR.)

WOMEN FIRE TOWER ATTENDANTS. Beginning in 1941, women were recruited to "man" the state's fire lookout towers. Most were married, and many were related to forest wardens already employed by the department. The women earned the respect of their coworkers, and (unlike women in defense industries) most retained their jobs after the war ended. Sadly no original photographs of the female fire tower attendants from the World War II period survive. (*Baltimore Sun.*)

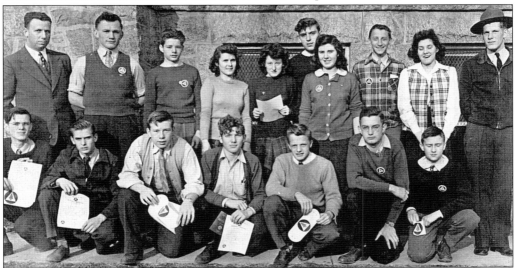

HIGH SCHOOL FIREFIGHTING CREW. During World War II, many of the Maryland Department of Forests and Parks field staff were pressed into military service, forcing the agency to find creative means to fight forest fires. As part of their civil-defense training, high school students like the ones pictured here were organized into forest fire-fighting brigades. (DNR/Paul Seward.)

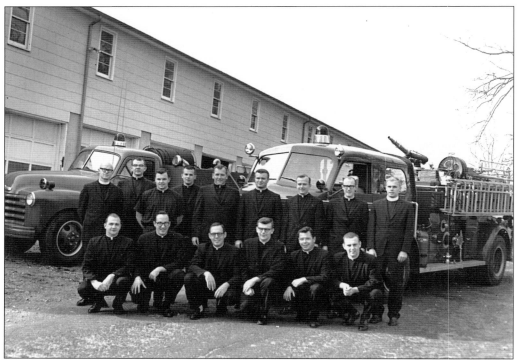

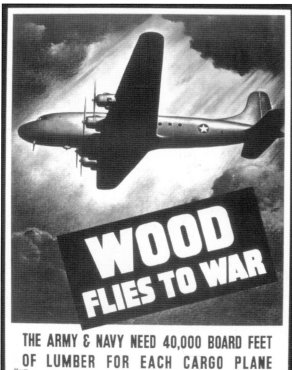

WOODSTOCK FIRE BRIGADE. Perhaps the most unique firefighting brigade from the Second World War was the one stationed out of Woodstock College in western Baltimore County. Composed entirely of Jesuit brothers, the brigade was praised as one of the most effective firefighting crews in the state and continued to serve with distinction into the 1960s. (DNR.)

WOOD FLIES TO WAR. Besley's efforts to protect Maryland's forests met their greatest challenge during the Second World War, when the state's timber resources were stretched thin. In response, the state authorized the Forest Conservancy Districts Act, which greatly increased the Maryland Department of Forests and Parks' authority to enforce responsible forestry practices. This U.S. Army advertisement served to remind Americans of the importance of the nation's timber resources. (National Archives.)

SMOKEY BEAR. To discourage the setting of forest fires during the Second World War, the U.S. Forest Service created the fictional character Smokey Bear. Smokey has since become one of the most recognizable figures in American history—especially after the advent of the "real" Smokey Bear in the 1950s. The Maryland Department of Forests and Parks jumped on the Smokey bandwagon, using the image in this 1956 advertisement. (DNR.)

BUSY PARKS. Though visitation ebbed and flowed during the war, parks such as Gambrill (pictured here two years before the war) remained busy, especially on weekends. (DNR.)

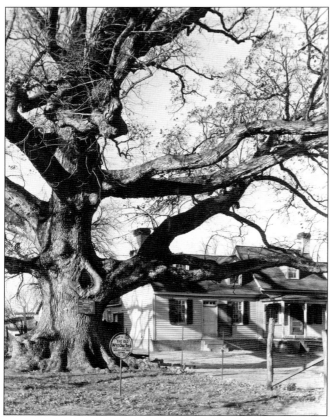

WYE OAK STATE PARK.
Fearing that every champion tree might become a state park, Besley initially opposed state acquisition of the Wye Oak. A flood of popular support, however, led to the ancient tree becoming a state park anyway in 1939. Years before it became state property (this photograph was taken in 1936), local residents were already promoting the tree as a tourist attraction. (EPFL.)

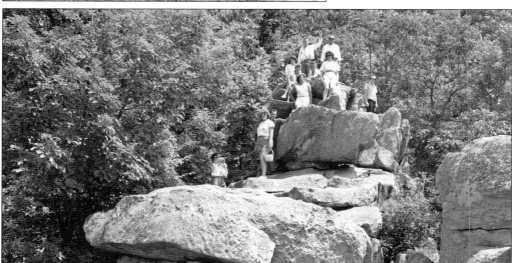

DEER CREEK STATE PARK. In the 1950s, the Maryland Department of Forests and Parks began to expand river valley parks to protect the state's water supply. Among the first riparian environments acquired was Deer Creek in Harford County. Deer Creek soon became a popular picnicking destination, and it continues to attract crowds today as Rocks State Park. Here visitors pose on the King and Queen seats on July 9, 1961. (DNR.)

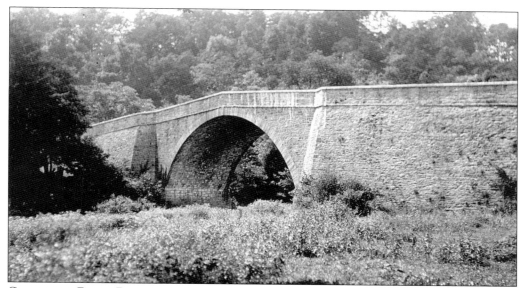

CASSELMAN RIVER BRIDGE STATE PARK. In the 1950s, the State Roads Commission installed several roadside picnic areas along major highways. The Roads Commission operated most of these facilities, but in Grantsville, the Maryland Department of Forests and Parks acquired the picnic area near the Casselman River Bridge in 1957. The stone bridge (shown here in 1929) was originally built for the National Road in 1813 and was one of largest bridges in America upon completion. (EPFL.)

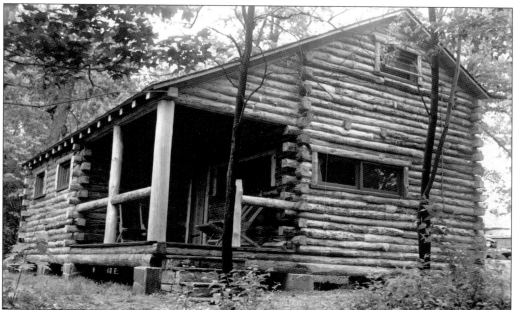

NEW CABINS AT HERRINGTON MANOR. So popular were the cabins at New Germany and Herrington Manor that four new cabins were installed at the latter in 1953, bringing the park's total to 20. Limited accommodations, however, remained a consistent problem throughout the postwar period. Unwilling to turn patrons away, many parks resorted to carving ad hoc campsites out of the forest. (DNR.)

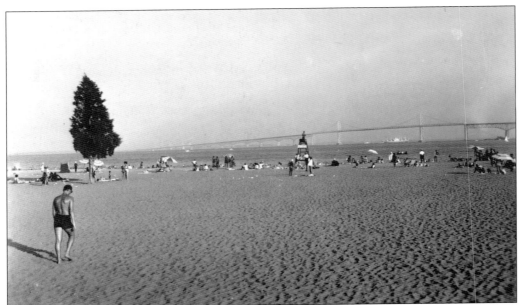

SANDY POINT STATE PARK. Because beach facilities were not installed at Elk Neck State Park until 1959, Sandy Point became the first true Chesapeake Bay park. Acquisition began in 1948, and the park opened to the public in 1952—the same year as the neighboring William Preston Lane Jr. Memorial Bridge (or Chesapeake Bay Bridge) opened, seen in the background of this July 1961 photograph. (DNR.)

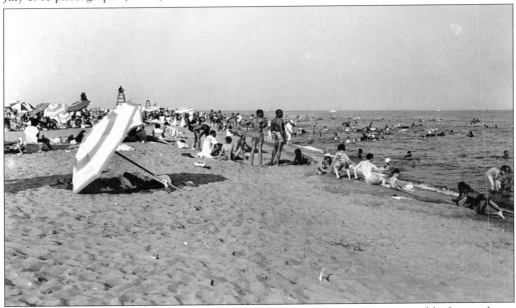

SEGREGATION AT SANDY POINT. When Sandy Point first opened, it regrettably featured two beaches: a large beach for white patrons and a smaller beach for blacks. Officially sanctioned segregation did not last long, however. In 1955, both Baltimore City and Maryland State Parks were desegregated, but litigation dragged out implementation for another year. As this July 1961 photograph illustrates, true integration did not proceed quickly. (DNR.)

CUNNINGHAM FALLS STATE PARK. In 1954, the federal government turned about half (4,446 acres) of the Catoctin Recreation Demonstration Area (now Catoctin Mountain National Park) over to the Maryland Department of Forests and Parks. Renaming the preserve Cunningham Falls State Park, the department built a large picnic area close to the park's main feature, a cascade (or "falls") along the Big Hunting Creek, seen here in the late 1950s. (DNR/M. E. Warren.)

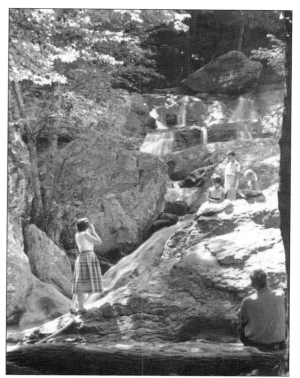

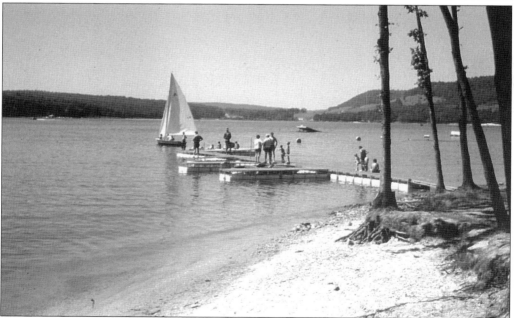

DEEP CREEK LAKE STATE PARK. Located on the shore of Maryland's largest lake, Deep Creek State Park became one of state's most popular parks after it opened in 1959. It featured modern bathing facilities, a campground, and picnic area. The lake, built by the Pennsylvania Power and Light Company in 1924, is ideal for swimming, boating, and water-skiing. (DNR.)

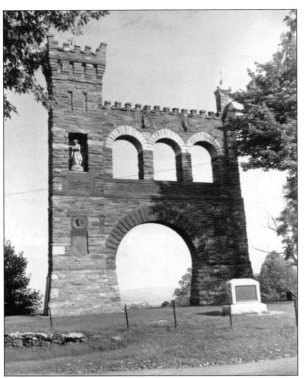

GATHLAND WAR CORRESPONDENTS ARCH. Built by journalist George Alfred Townsend in 1896, the arch paid tribute to 157 fellow Civil War correspondents and artists (from both North and South). Located near Townsend's summer home outside Burkittsville, the arch is presently owned by the National Park Service. The surrounding buildings and grounds were deeded to the State of Maryland on May 13, 1949, and became Gathland State Park. (DNR.)

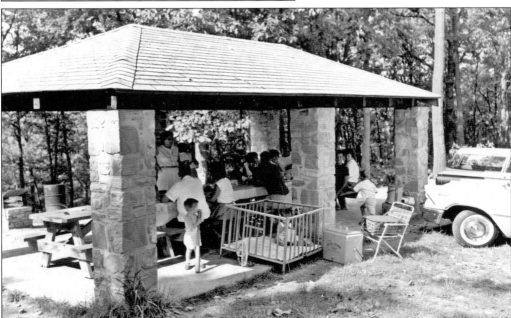

MCKELDIN AREA OF PATAPSCO. By the late 1940s, many complained that Patapsco State Park's recreational amenities fell far short of their potential. To address this, assistant forester Karl Pfeiffer helped expand and modernize the park. These efforts culminated in establishment of a new section near Marriotsville in 1958. It was named in honor of Gov. Theodore McKeldin. (DNR.)

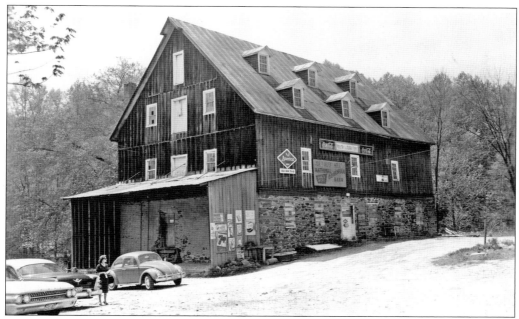

JERUSALEM MILL. Acquisition of stream valley parks during the 1960s was possible because many industries no longer depended upon waterpower. By the time the Maryland Department of Forests and Parks acquired Jerusalem Mill along the Gunpowder River in 1961, it was functioning as a general store and a gristmill. Soda and beer advertisements still covered the building at the time this photograph was taken in May 1962. (DNR.)

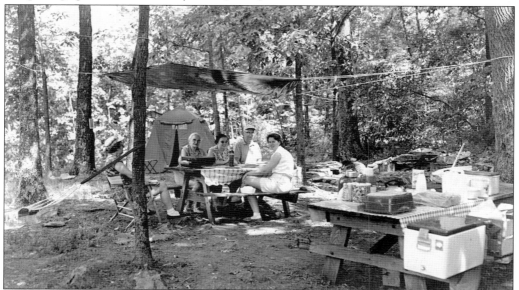

CAMPING. By the mid-20th century, campers had a wide variety of products designed for outdoor recreation to choose from, including tents and campers, sleeping bags, coolers, lanterns, and station wagons—ancestors to the present sport-utility vehicles. The Maryland Department of Forests and Parks provided a camping pad, picnic tables, and a barbeque grill or fireplace. Here a family enjoys a late summer day at Washington Monument State Park on September 4, 1961. (DNR.)

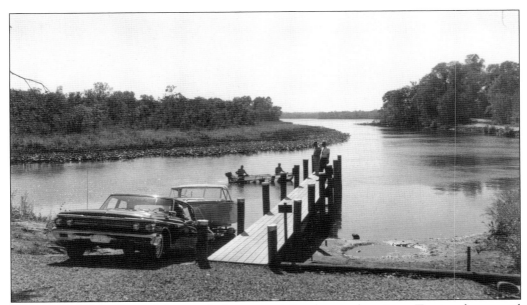

MARTINAK STATE PARK. Many parks began as philanthropic donations. To give the general public an opportunity to appreciate the same idyllic environment he had come to enjoy, George Martinak donated his 99-acre summer retreat to the State of Maryland in 1961. Two years later, the Maryland Department of Forests and Parks installed several picnic areas and a boat launch facility (pictured here in the mid-1960s). (DNR.)

ASSATEAGUE STATE PARK. Some philanthropic donations were motivated by profit. At Assateague, a developer hoped to attract home buyers by encouraging the state to build a park on a small portion of the island. A nor'easter in March 1962 (the results of which are illustrated here) dashed the developer's plans, and the rest of the island north of the Virginia line was turned over to the National Park Service in 1965. (DNR.)

WESTVACO. Demand for wood products continued unabated during the postwar period. In a scene reminiscent of the early 20th century, the West Virginia Pulp and Paper Company at Luke (seen here in 1961) was one of the largest consumers of wood products in Maryland. The plant continues to operate today as part of the New Page Corporation and currently owns over 1.35 million acres of forestland in the eastern United States. (DNR.)

SPRAYING CHEMICALS. In the postwar period, chemicals were increasingly employed to kill pesky invaders such as white pine weevils and Japanese honeysuckle. Many chemicals, such as DDT, often carried unintended consequences, such as killing off desired animals and plants. Moreover, as this 1960s photograph illustrates, few safety precautions were taken—note the lack of rubber gloves, goggles, or gas mask. (DNR.)

BUCKINGHAM NURSERY. The demand for trees overwhelmed resources at College Park, and a new nursery was opened at Harmans in Anne Arundel County in 1955. Later named the Buckingham Tree Nursery, it was located near present-day Thurgood Marshall Baltimore-Washington International Airport. The forest service sold the property in the mid-1990s to make way for Maryland Route 100. Here Boy Scouts are given a lesson in tree planting in March 1970. (DNR.)

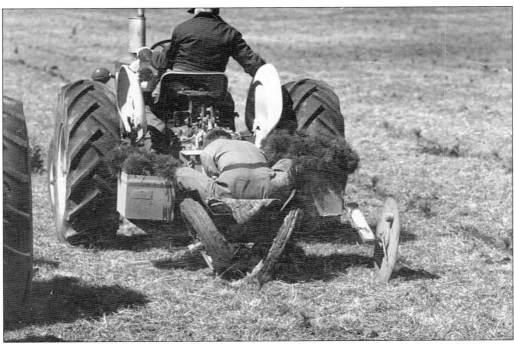

MECHANICAL TREE PLANTER. Sometimes small advances in technology can have a profound effect; one case in point is the mechanical tree planter. Prior to the development of this machine, all trees were planted by digging a hole with a shovel. (DNR.)

FOREST PATROL PLANE. By the 1950s, the Maryland Department of Forests and Parks began to employ airplanes to spot forest fires. Forest supervisor Herman Toms prepares to take off at a forestry demonstration at the Frederick City Fair on August 30, 1962. (DNR.)

FOREST PATROL JEEP. On the ground, the Maryland Department of Forests and Parks employed all-terrain vehicles such as this Jeep, which came equipped with a water tank, Panama fan-driven pump, and hose. (DNR.)

BOYS' FORESTRY CAMPS. In cooperation with the State Department of Public Welfare, Boys Forestry Camps were established in 1955 to rehabilitate delinquent young men over the age of 15. Quartered at former CCC campsites, the boys engaged in forest conservation work at Green Ridge, Savage River, and (later) Potomac State Forest. In 2005, the Boys' Forestry Camps celebrated their 50th anniversary and continue to provide opportunities for hundreds of teenagers annually. (DNR.)

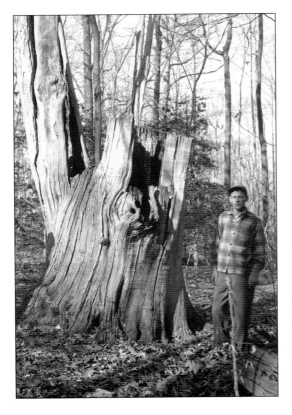

AMERICAN CHESTNUT. In the late 1950s, a forester poses next to a remnant of what had been one of the nation's dominant trees. In 1904, a deadly fungus was accidentally introduced into New York's Bronx Zoo, and within three decades, virtually every American chestnut of substantial size was dead. Efforts to stop the blight proved fruitless, and many dying trees were harvested to salvage their valuable, rot-resistant lumber. (DNR.)

Six

THE SPENCER ELLIS ERA
Big Budgets, Big Visions, and Big Plans

In 1964, Samuel L. Hammerman, chairman of the Maryland Forest and Parks Commission, hired Spencer P. Ellis to be director of the Maryland Department of Forests and Parks. A landscape architect by training, Ellis was the first park professional to run the agency.

Ellis wasted little time. He hired a group of young professional park planners who immediately penned a 10-year park development plan in 1966. Reflecting the optimism of the mid-1960s, the *Master Plan for Outdoor Recreation: 1967–1976* called for $7.5 million to develop golf courses, amphitheaters, swimming pools, nature and visitor centers, and museums to go along with new roads, pavilions, campgrounds, cabins, and lakes. According to the plan, "the value of a good park system cannot be questioned. The benefit of a park goes far beyond a dollar consideration." Moreover, "it can be said that State Parks pay for themselves. The point is not whether the State can afford the capital expenditure for additional facilities but rather that Maryland must take advantage of this proven economic stimulus." Like the park plans from the previous decade, these new park plans centered on automobile access and accommodation.

Grand plans coupled with matching federal funds led to dramatic land acquisition and a park building spree. Beginning in the mid-1960s and lasting until the funds began to run dry in the mid-1970s, dozens of Maryland parks received modern amenities and facilities. These parks included Assateague, Cedarville, Greenbrier, Gunpowder, Patapsco, Pocomoke, Point Lookout, Rocky Gap, Seneca, and Susquehanna, forming the nucleus of the modern Maryland State Park System.

Among Ellis's most notable accomplishments was his assistance in the creation of Program Open Space in 1969. The program used real estate title transfer tax money to purchase lands for parks, forests, and environmental areas. Widely regarded as one of the first effective open-space preservation programs, it served as the model for all similar programs in other states. In its first 20 years, it added nearly 60,000 acres to Maryland's state park holdings—a 57 percent increase—and thousands more acres to Maryland state forests.

SAMUEL L. HAMMERMAN. Gov. J. Millard Tawes appointed Hammerman (right foreground, a real estate developer from Baltimore, to the forest and parks commission in 1961, making him chairman in 1963. Under Hammerman's leadership, the department began an intensive facility development campaign. Hammerman died in January 1965; however, aggressive facility development continued for the rest of the decade. The Hammerman Area of Gunpowder Falls State Park was named in his honor. (DNR.)

SPENCER P. ELLIS. A decorated war veteran with a master's degree in landscape architecture from Texas A&M, Ellis (center) became the first park professional to direct Maryland state forests and parks. He recast the agency, making park development central to his agenda. In 1966, Ellis received the Meritorious Service Award from the National Recreation and Parks Association. Ellis later served as an assistant secretary in the Department of Natural Resources. (DNR.)

J. Millard Tawes. Save perhaps Theodore McKeldin, no governor was more proactive in encouraging state park development than Tawes. On October 16, 1962, Tawes uses a chainsaw to cut down the first tree at what would become the lake at Greenbrier State Park. Joe Kaylor (right) nervously looks on. (DNR.)

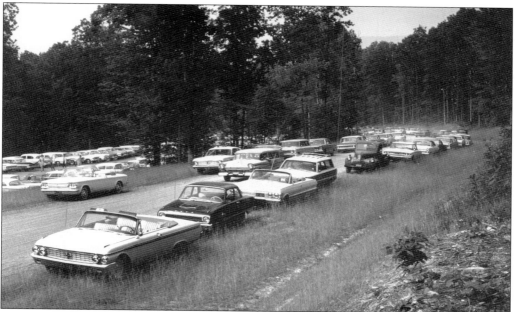

Greenbrier Parking Lot. During the 1960s, park and highway development went hand-in-hand. More roads, however, meant more cars, and the consequences were obvious. Despite only having a handful of facilities ready for public use, Greenbrier is already overwhelmed by automobiles during its first summer in 1966. (DNR.)

PLANNING DIVISION. Charged with creating Ellis's park plans were a group of young landscape architects, planners, engineers, and recreational specialists, including (clockwise from top left) Marie Townsend, Charlie Cadle, William Offutt Johnson, Ed Heath, and Gene Cheers. Johnson later recalled, "As the massive park building program got going, there grew a greater appreciation for the Planning Division staff when it became obvious of the huge amount of work they handled." (DNR.)

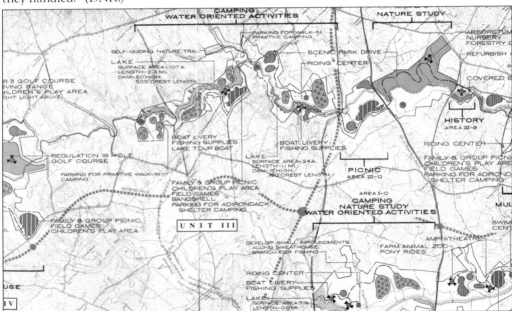

GRANDIOSE PLANS. As this plan for Gunpowder Falls State Park illustrates, the park development plans reflected the optimism and budgets of the mid-1960s. The plan included a regulation 18-hole golf course, horse riding center, nature center, family camping areas, arboretum, bird sanctuary, and a lake complete with boat rentals and tour boat rides—none of which were ever developed. (DNR.)

BUILDING LAKES. Like their Depression-era counterparts, many of the new parks featured lakes—despite the fact that Maryland possesses no natural lakes. New lakes were constructed at Rocky Gap, Greenbrier, Cunningham Falls, Tuckahoe, and Seneca Creek (pictured here in November 1975). Other parks plans, such as at Gunpowder Falls, also included lakes. (DNR.)

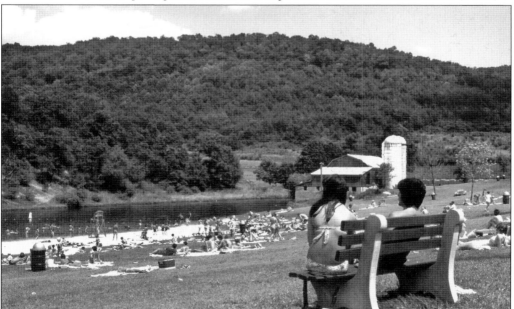

ROCKY GAP BEACH. One of the few parks to largely live up to its master plan, Rocky Gap State Park featured the 243-acre Lake Habeeb, a beach and swimming area, bathhouses, amphitheaters, and over 250 individual campsites. A golf course, lodge, and conference center were added in the 1990s. Vestiges of the park's agricultural heritage, however, were still present in August 1970. (DNR.)

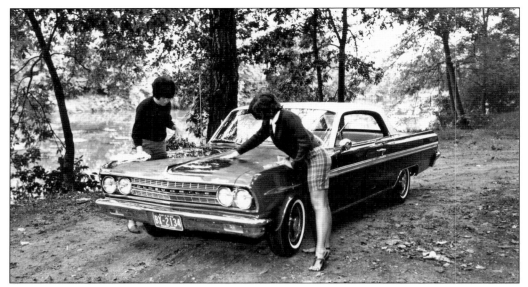

WAXING CARS AT PATAPSCO. Prior to Tropical Storm Agnes in 1972, River Road was a popular through route between Ellicott City and Elkridge. The Avalon and Orange Grove areas featured several pull-offs where park patrons could picnic by the riverside. Many locals liked to bring their automobiles to the park and wax them under the shady trees, as Christine Zencker and Angela Connolly demonstrate on September 14, 1964. (DNR.)

CORRESPONDENTS HALL OF FAME MUSEUM. Gathland's surrounding countryside has changed little since it became a state park in 1949. In 1962, however, there were plans to build a war correspondents museum and amphitheater near Townsend's famous arch. On September 7 of that year, dignitaries (including Governor Tawes) and the press gather to witness the development plans revealed. The plans never came to fruition. (DNR.)

ASSATEAGUE PONIES. Assateague became one of the most intensely developed and patronized state parks in Maryland, featuring hundreds of campsites and a dozen bathhouses. While the island features one of the most diverse ecosystems in the state, its main attraction remains the beach and the famous ponies (pictured here on June 24, 1966). Though many plausible theories have surfaced, just how the ponies arrived on the island is still a mystery. (DNR.)

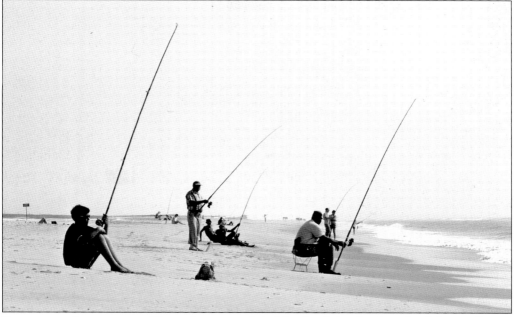

FISHING AT ASSATEAGUE. The only state park in Maryland that borders the Atlantic Ocean, Assateague State Park is a popular destination for ocean fishing. On June 24, 1966, fishermen wait patiently for a shark, croaker, or flounder to bite. (DNR.)

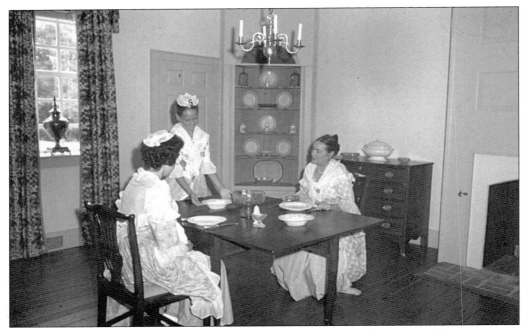

SMALLWOOD INTERPRETATION. Interpretation in Maryland State Parks was initially nonexistent, and then it was sporadic. At Smallwood State Park, the former home of Revolutionary War hero Gen. William Smallwood, volunteers occasionally staffed the building in period costume. The interpretation presented in this August 22, 1961, photograph illustrates a stereotyped portrayal of life in the late 18th century. (DNR.)

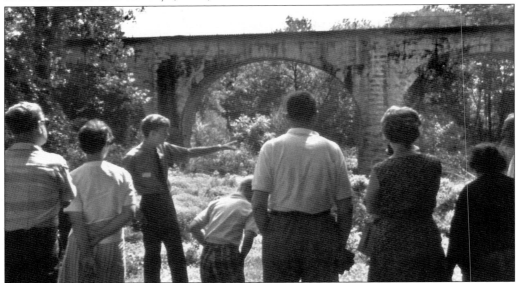

RIVER OF HISTORY TOUR. In 1968, Spencer Ellis declared, "Interpretation will play a key role in ultimately solving such problems of environmental ecology as pollution of air and rivers, urban and suburban blight and destruction of soil, trees, and mineral deposits." True to his word, Ellis endorsed an extensive interpretive program. Here Patapsco State Park naturalist Jim Rogers leads a talk on the Thomas Viaduct, one of the nation's oldest railroad bridges. (DNR.)

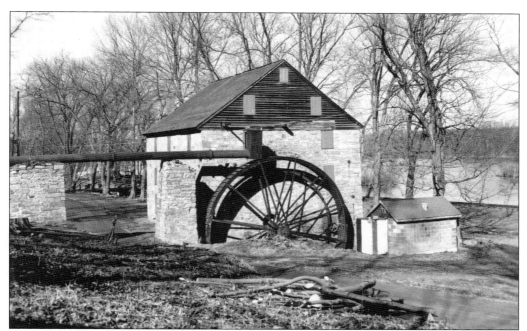

ROCK RUN GRISTMILL. Located in Susquehanna State Park, Rock Run gristmill became a notable historic restoration project during the Ellis years. The Maryland Department of Forests and Parks purchased the Rock Run complex remains in 1962, including the mill (originally built by John Stump in 1794), the miller's house, nearby Rock Run mansion, and the Jersey Tollhouse. Above is the mill as it appeared shortly after the department first acquired it in January 1962. By the summer of 1970, the department reconditioned the mill's machinery and hired an interpretive staff to operate it. Plans to restore the nearby tidewater canal, however, fell through as budgets declined in the 1970s. Below is the mill in the summer of 1976. (DNR.)

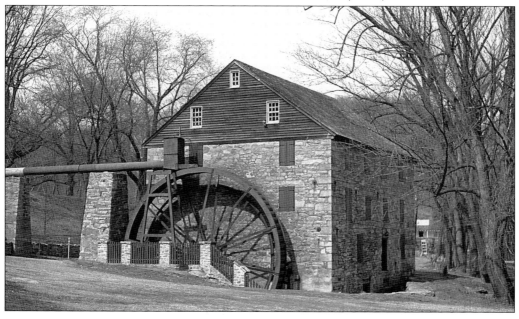

FIRST MARYLAND REGIMENT. In 1965, military history enthusiasts organized the First Maryland Regiment. The regiment began a long and fruitful relationship with the Maryland Office of Tourism and the Maryland Department of Forests and Parks by staging living history demonstrations at Fort Frederick and other state parks. Their popularity helped lead to the restoration of the troop barracks at Fort Frederick in 1976. The regiment disbanded in 1981. (DNR.)

BRAILLE TRAIL. In an effort to make parks appealing to everyone, a "Braille Trail" was dedicated in the McKeldin Area of Patapsco State Park in May 1972. Intended to give the blind an opportunity to experience nature, the trail consisted of a series of ropes connecting Braille interpretive signs with audio recordings. The trail, however, was expensive to maintain and was frequently vandalized. Today the dedication plaque remains, but the interpretive signs and ropes are gone. (DNR)

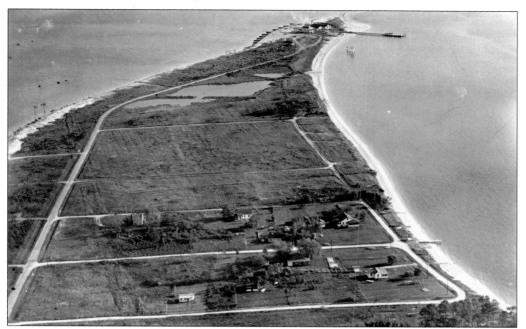

POINT LOOKOUT STATE PARK. Few places have such a split legacy. While Point Lookout has served as a vacation spot since the mid-19th century, it also served as a prison camp for captured Confederates during the Civil War. A popular resort in the early 20th century, the point's resort was in significant decline by the time the state acquired the property in 1962. This aerial photograph was taken in January 1963. (DNR.)

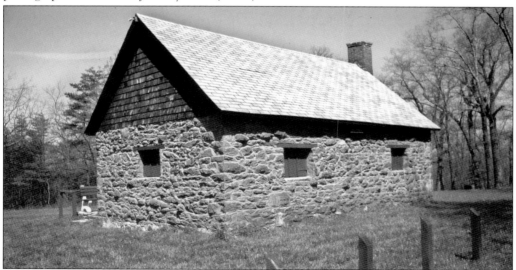

SOLDIERS DELIGHT NATURAL ENVIRONMENTAL AREA. Few parks better reflect the influence of grassroots initiative. In 1965, local activists organized Soldiers Delight Conservation, Inc., to lobby the state to purchase the western Baltimore County property. The first state acquisition occurred in 1969. Noted for its unique geological feature—the serpentine barrens—Soldiers Delight Natural Environmental Area is today home to more than 36 rare and endangered plant species. (DNR.)

PROGRAM OPEN SPACE (POS). The product of a coalition effort that included Spencer Ellis and state senators James A. Clark Jr. and William S. James, POS has been the key land preservation program in Maryland since 1969. Half of POS money is allocated to county and local governments for park development; the other half goes to DNR for land preservation. POS money went towards the creation of Downs County Park in Anne Arundel County—seen here in 1990. (Offutt Johnson.)

POLLUTION. While fear of global warming and declining biodiversity rank among the highest environmental concerns today, during the 1960s, environmentalists were most concerned about pollution—air, land, or water. Despite the efforts of the Maryland Department of Forests and Parks to create clean stream valleys, curbing pollution proved a persistent challenge. In 1962, park supervisor Ozzie Hebert points out an unidentified piece of debris in the Little Gunpowder River. (DNR.)

Seven

MODERN TIMES
New Realities and
New Opportunities

In 1969, the state government organized the Department of Natural Resources (DNR) to coordinate all the state's natural resource agencies, including the Department of Forests and Parks. Three years later, the Maryland Department of Forests and Parks was split into the Maryland Park Service and the Maryland Forest Service, formally separating parks and forests. This bureaucratic change, while logical, nevertheless ultimately eroded the authority and influence forests and parks once enjoyed relative to other natural resource agencies. Land acquisition responsibilities (including Program Open Space) and infrastructure development were moved to a new agency, Capital Programs Administration.

Meanwhile, hard economic realities of the 1970s forced a reevaluation of Ellis's ambitious development plans. As budgets dwindled, most of Ellis's plans were scaled back. Pete Bond and Bill Parr, Ellis's successors in forests and parks respectively, instead focused on maintaining existing facilities and making do with less. Thanks to Program Open Space, land acquisition continued largely unabated, while operating budgets and infrastructure remained largely unchanged.

Most park and forest users today are thankful that the grand park development plans never came to fruition. As time passed, many people sought means to escape from their automobiles rather than enjoying parks through them. The undeveloped parks and forests thus became popular places for hiking and biking, allowing visitors to get more in touch with nature. Had the park development plans of the 1960s become a reality, many feel that the scenic and natural beauty of the state's public lands would have been lost.

As the park development plans fizzled, a renewed emphasis on conservation took center stage, and the declining condition of the Chesapeake Bay forced Maryland's natural resource agencies to shift their emphases. As highway building and suburban expansion continued, Maryland's state forests and parks became bastions for not only providing outdoor recreation, but also protecting sensitive ecosystems, thus playing an important role in protecting the Chesapeake Bay. Maryland state forests and parks embarked on an effort to educate the general public about conservation and environmental protection by expanding interpretive programs first established in the late 1960s.

PATUXENT RIVER. Few parks better symbolize the unfulfilled 1960s development plans. Conceived in 1963 as a stream valley park complete with campgrounds and pavilions, Patuxent River State Park is now Maryland's fourth largest state park. No facilities, however, were ever developed, and the park is managed by nearby Seneca Creek State Park. Today the park is popular among fishermen, hikers, and horseback riders, like the one pictured here in October 1975. (DNR.)

TROPICAL STORM AGNES. Grandiose park development plans hit more than budgetary snags—Mother Nature also provided obstacles. In June 1972, Tropical Storm Agnes removed chunks of Patapsco State Park's River Road, a major park road and connector route between Ellicott City and Elkridge. The road was never reopened west of Orange Grove. After Agnes, park planners shifted Patapsco's emphasis from accommodating car-dependent picnickers to hikers and mountain bikers. (DNR.)

JANES ISLAND. Determined to build parks in every part of the state, the Maryland Department of Forest and Parks established Janes Island State Park in Somerset County in 1967. Once home to a thriving oyster industry, the ghostly remnants of which are visible here in October 1971, the island is now largely a wildlife sanctuary. The island itself is only accessible by boat, but modern park facilities were built on the nearby mainland. (DNR.)

SAVE OUR STREAMS. During the 1960s, concern over pollution led to the formation of grassroots environmental initiatives across Maryland and the nation. Among those initiatives was Save Our Streams (SOS). Organized in 1969, SOS provided residents with an opportunity to monitor pollution on local streams and rivers. In June 1974, two SOS members examine the Patuxent River's water quality. (DNR.)

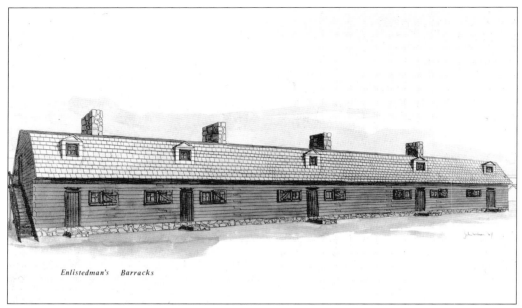

Enlistedman's Barracks

TROOP BARRACKS MOCK-UP. In preparation for the nation's 1976 bicentennial, the Maryland Park Service embarked on an effort to restore the troop barracks at Fort Frederick. At first, there was no evidence indicating the actual design of the long-vanished buildings. Forced to work with circumstantial evidence, a volunteer developed this conceptual plan in the late 1960s. (DNR.)

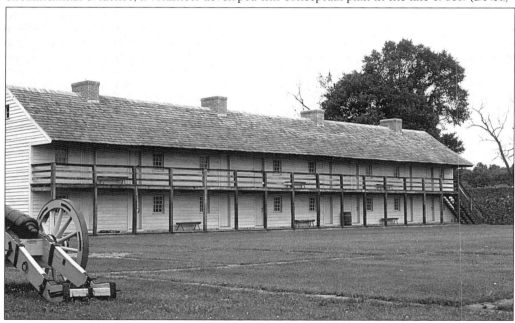

TROOP BARRACKS RESTORED. Fortunately, shortly before construction began, new evidence revealed that the troop barracks originally were wooden frame buildings with porches. The centerpieces of the Maryland State Park Service's bicentennial celebration, the restored barracks were completed in the winter of 1976. Fort Frederick, which celebrated its 250th anniversary in 2006, remains a popular destination for history enthusiasts. (DNR.)

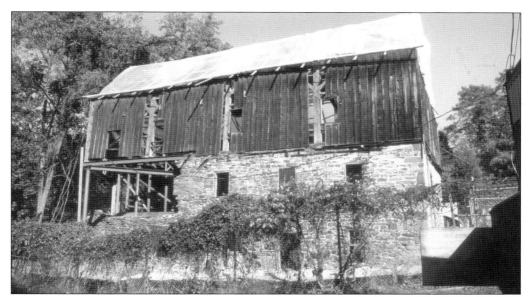

JERUSALEM MILL IN RUINS. As budgets shriveled during the 1970s and 1980s, many irreplaceable historic structures fell into disrepair. After three decades of neglect, Jerusalem Mill (see page 87) was in deplorable condition by October 1993. However, a group of dedicated volunteers, the Friends of Jerusalem Mill, was not discouraged. Organized in 1985, the Friends began a decade-long effort to restore the mill. (DNR.)

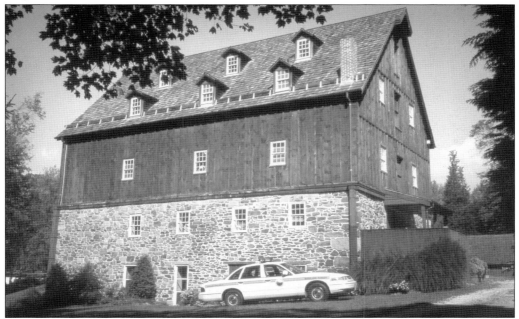

JERUSALEM MILL RESTORED. By October 2003, visitors would be hard-pressed to find evidence of neglect. The Friends of Jerusalem Mill lobbied the state to restore the mill, and it now serves as a museum, gift shop, and park headquarters. The Friends, meanwhile, have worked to restore the village, including the blacksmith shop and gunsmith shop, and are currently restoring the general store. (DNR.)

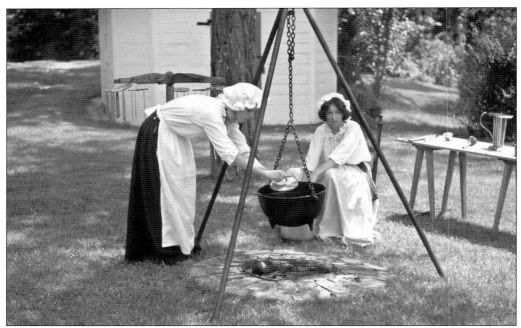

LIVING HISTORY. In the 1970s, the Maryland Park Service hired historian Ross Kimmel and implemented a series of living history programs at Fort Frederick, Susquehanna, Smallwood, and elsewhere. Unlike previous forays into living history (see page 100), the new programs attempted to convey a more accurate portrayal of life in the past. At Smallwood in June 1978, Debra Pence (left) and Susan Gruss demonstrate how candles were made in the 18th century. (DNR.)

GREENWELL. Like many parks, Greenwell State Park began as a philanthropic donation. Unlike previous donations, however, Philip and Mary Wallace Greenwell's 1971 donation stipulated that their former St. Mary's County farm be developed as an all–handicap accessible park. Plans were developed by 1976, but they were never implemented. A partnership with the Greenwell Foundation, Inc., organized in 1993, however, has initiated efforts to fulfill the original vision. (DNR.)

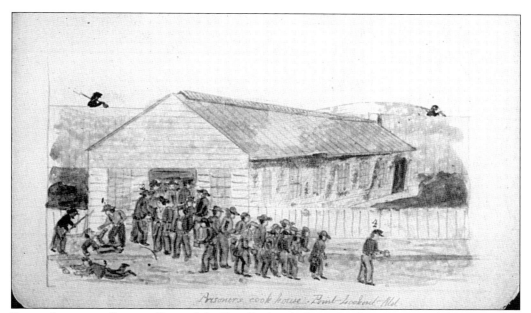

POINT LOOKOUT PRISON CAMP. Like Fort Frederick, Point Lookout State Park has become a popular attraction for historians and history enthusiasts. While conditions in most Civil War prison camps were harsh, there is still controversy over the extent of prisoner abuse at Point Lookout. Portions of the camp's outer wall (visible behind the mess hall in this drawing done by a former prisoner of war) have been restored. (DNR.)

TAWES GARDEN. In 1977, Helen Avalynne Tawes and her husband, former governor J. Millard Tawes, plant a loblolly pine at a new garden on the grounds of the new DNR office complex. The garden, named in honor of Mrs. Tawes, provides visitors with an opportunity to see plants from every part of Maryland. (DNR.)

JUNIOR RANGERS. In 1976, the Maryland Park Service initiated the Junior Ranger program to involve children between the ages of 8 and 14 in conservation projects in state parks. Initially a three-year program, in the 1980s, it was expanded into a five-year program and included more formal educational courses. Still thriving today, the Junior Ranger program draws over 1,500 participants annually. (DNR.)

SCALES AND TALES. One of the most popular programs run by the Maryland Park Service, Scales and Tales was started in 1986 by naturalist Bill Trautman (pictured here) at Gunpowder Falls State Park. The program features un-releasable birds of prey and reptiles and is regularly featured in schools and events across Maryland. Interpreters emphasize the benefits public lands provide and the dangers of careless behavior, such as littering. (Johnson.)

CURATORSHIP PROGRAM. In the process of acquiring new public lands, DNR inherited a collection of abandoned and unused structures. With few management plans (and funds) in place, many of the structures fell into disrepair. In 1982, Larry and Agnes Bartlett spotted their dream home, an abandoned stone house, in rural Baltimore County in Gunpowder Falls State Park. Unable to purchase the property from DNR, the Bartletts proposed to lease the property for life and restore it. DNR agreed. Within five years, the Bartletts had completely transformed the stone hulk into the home seen below. Impressed by the Bartletts' ingenuity, DNR began the resident curatorship program, whereby DNR structures are leased to tenants with the understanding that they will restore and maintain them. Initially managed by the Maryland Forest and Park Service, the program is now managed by DNR's Land and Property Management unit. (DNR.)

MARYLAND PARK RANGERS. By 1977, park rangers had to complete a rigorous program, including training, before being certified as law enforcement officers. Truly jacks-of-all-trades, rangers had to have college degrees in the natural sciences and be willing to do law enforcement, conservation, and interpretive work. Pictured here is the 1977 graduating class, which included future Maryland Forest and Park Service superintendent Rick Barton (third row, fifth from left). (DNR.)

LAW ENFORCEMENT RANGER. By the late 1970s, some Maryland state parks began to witness undesirable human behavior, including crime. To better protect the public and the resources, Maryland park rangers were given more formal police training and began to carry sidearms. Many parks saw a noticeable improvement in safety and security by the mid-1990s. Ranger Jerry Kirkwood poses next to his patrol vehicle in 2000. (DNR.)

TIRE PARK PLAYGROUNDS. Always looking for new ways to help the environment, the Maryland Forest and Park Service, through a partnership with the Maryland Environmental Service and the Maryland Department of the Environment, built several tire park playgrounds, like this one built at Tuckahoe State Park in the mid-1990s. Instead of using plastic materials and wood mulch, the park service has employed recycled fibers and used tires. (DNR.)

MARYLAND CONSERVATION CORPS (MCC). Established in 1984 as part of the Chesapeake Bay program initiative, the MCC initially hired young adults to do conservation work along the tributaries of the Chesapeake Bay during the summer. It was expanded into a statewide, year-round program in 1992 and continues to provide opportunities for young adults today. In the spring of 1994, Eric Richter (foreground) and Mike Reese (background) build a boardwalk through Echo Hill in Kent County. (DNR.)

OUTDOOR DISCOVERY. Established in 1985 as a joint program between the Baltimore City Parks and the Maryland Forest, Park, and Wildlife Service, Outdoor Discovery Camps give children between the ages of 8 and 17 an opportunity to spend a week camping outdoors in many state forests and parks. In the summer of 2003, ODC participants take a ride on a sailboat off the coast of Elk Neck State Park. (DNR.)

VOLUNTEERS. With operating demands continuing to outpace operating budgets, the Maryland Park Service has increasingly turned to volunteers for assistance. Volunteers often lead interpretive programs, staff visitor centers, maintain trails, and (in a testament to the old forest wardens) patrol trails on horseback. In 2003, Brenda Dorsch (left) and Beverly Raymond (right) staff one of Maryland State Fair's most popular attractions, the DNR tent. (DNR.)

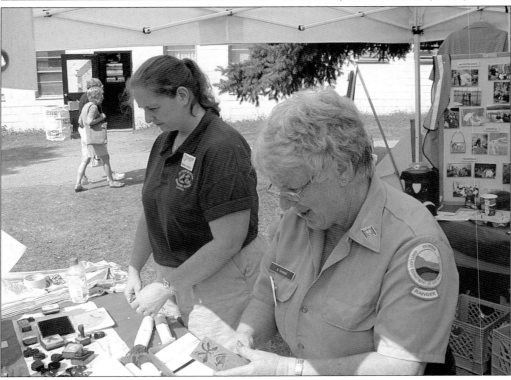

CHOPTANK RIVER FISHING PIER. When U.S. Route 50 was realigned in 1987 to make way for a new four-lane bridge at Cambridge, the original two-lane bridge was spared and converted into a fishing pier managed by the Maryland Forest, Park, and Wildlife Service. Still managed by the park service today, the Choptank River Fishing Pier draws over 35,000 visitors annually. (Author.)

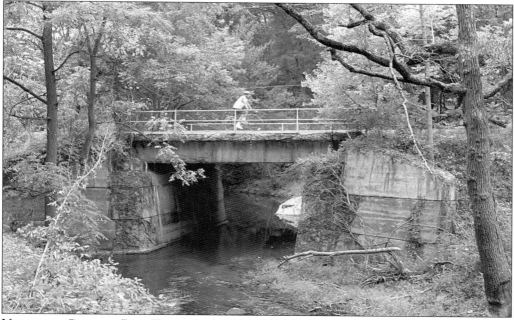

NORTHERN CENTRAL RAIL TRAIL. By the 1980s, DNR had adjusted its park development plans to include bikers, hikers, walkers, and joggers. Abandoned railroad right-of-ways proved ideal. In 1984, the state's first substantial rail-trail opened in Baltimore County. Operated by Gunpowder Falls State Park, the trail follows the abandoned Pennsylvania Railroad from Cockeysville north to the Pennsylvania line. York County parks in Pennsylvania later extended the trail to York. (Author.)

DISCOVERY CENTER. As part of an ongoing effort to provide exciting interpretive programs, the Maryland Forest and Park Service opened the Discovery Center at Deep Creek Lake State Park in 1999. The center features exhibits that appeal to patrons of all ages, including hands-on exhibits for children and historical- and cultural-themed exhibits for adults. Open year-round, the center's staff provides interpretive and interactive programs regularly throughout the day. (Author.)

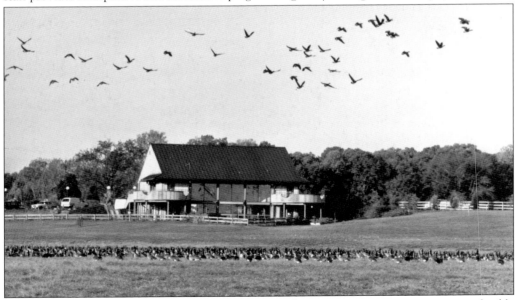

MERKLE WILDLIFE SANCTUARY. In the 1960s, the Canada geese migration route was in considerable danger. To address this, Edgar Merkle fed geese as they wintered on his Prince Georges County estate. After selling the land to the state in 1970, DNR organized the Merkle Wildlife Sanctuary. Still a haven for geese in the winter months, the sanctuary also features other animals, including red fox and great blue herons among others. (Offutt Johnson.)

CEDARVILLE. After the creation of DNR in 1969, the state's natural resource agencies began to work more closely in concert. Nowhere was the interagency cooperation more obvious than at natural resource management areas like Cedarville, where the park service, forest service, wildlife, fisheries, and various other agencies played a role in managing the facility. In the 1970s, Gene Piotrowski leads a public program on forestry. (DNR.)

CAMP HICKORY. In 1971, the Maryland Forestry Boards initiated a weeklong summer-camp program for high school students interested in conservation. The camp is currently run by the Hickory Environmental Education Center in Accident and is therefore known as Camp Hickory. Both professionals and volunteers instruct participants on everything from traditional forestry to urban forestry to watershed protection. Here soon-to-be state forester Stephen Koehn discusses management practices in 1999. (DNR.)

INVASIVE SPECIES. Since the 1950s, when the Maryland Department of Forests and Parks first noted problems associated with Japanese honeysuckle, invasive alien biological organisms have become an increasing nuisance. Invasive species are blamed for causing severe disruptions in the ecosystem, forming monocultures, and crowding out native wildlife. Controlling these species has proven a persistent challenge. Phragmites, pictured here at Sandy Point State Park, have overrun miles of critical wetland habitat in Maryland. (Author.)

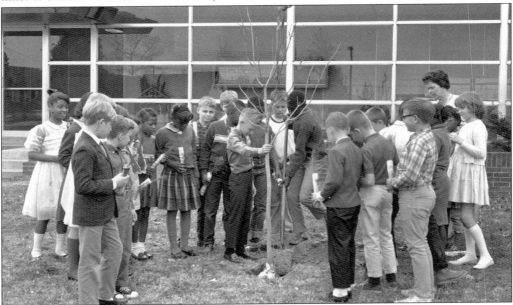

ARBOR DAY. Arbor Day is celebrated differently in each state. In Maryland, Arbor Day is celebrated annually on the first Wednesday of April. Since the days of Fred Besley, the State Board of Forestry and all its successors have celebrated Arbor Day by encouraging schoolchildren to plant trees on their campuses and local communities. On April 5, 1967, students at Fruitland Elementary plant a tree in front of their school. (DNR.)

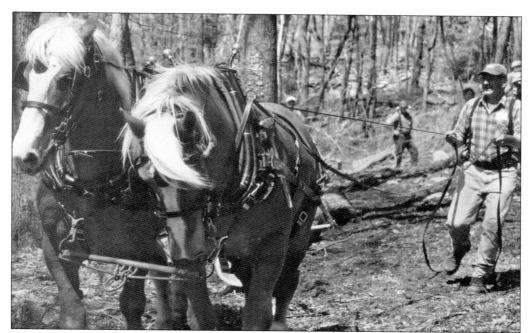

COOPERATIVE FORESTRY. A century after the State Board of Forestry was organized, cooperative forestry remains the lifeblood of the Maryland Forest Service. Today the Maryland Forest Service provides expert advice and consultation to thousands of private timber owners across Maryland, including Henry Maier, a farmer in the Town Creek watershed. Maier still uses horses (Prince and Barron) to log his property. (DNR/Dawne Fox.)

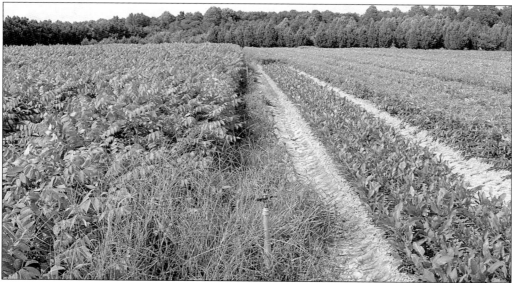

AYTON NURSERY. In a scene reminiscent of the early 20th century, black walnut and hickory seedlings soak in the sun at the John S. Ayton State Tree Nursery in the summer of 2006. After selling the Buckingham Nursery in 1995, nursery manager Ayton helped establish the Maryland Forest Service's new facility near Preston on the Eastern Shore. The 300-acre nursery produces over three million seedlings a year. (Author.)

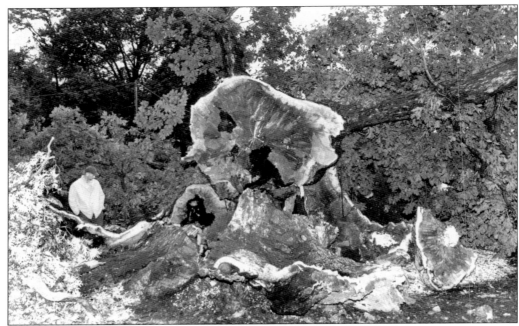

DEATH AND REBIRTH OF THE WYE OAK. The Wye Oak fell in a storm on June 6, 2002. The wood was salvaged and used to make a wide variety of artistic renderings as well as a new governor's desk in Annapolis. Thanks to the efforts of the Maryland Forest Service and the University of Maryland, a clone of the original tree was planted at Wye Oak State Park on June 6, 2006. (DNR.)

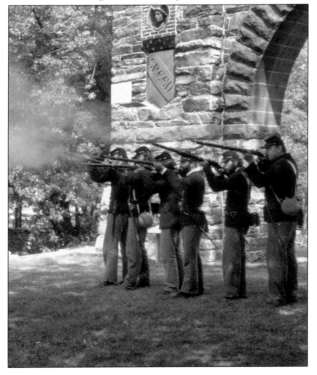

SOUTH MOUNTAIN STATE PARK. Today's Maryland Park Service is equally committed to protecting historical and natural resources. The state acquired South Mountain in the 1950s to protect the Potomac River's watershed. In the 1970s, however, South Mountain became recognized for its role in the Civil War. Reenactments such as the one here at Gathland in 1977 promote this legacy. Plans are in place to expand the park's historic interpretation. (DNR.)

CHESAPEAKE FOREST. In 1999, the Chesapeake Forest Products Company sold 58,000 acres of Lower Eastern Shore timberland. To protect the land, the state purchased 29,000 acres, and the Nature Conservancy purchased the other 29,000 acres. Reflecting the spirit of Robert and John Garrett, the Nature Conservancy then deeded the 29,000 acres to the state provided that it followed through on a state-of-the-art forest management plan. (DNR.)

CELEBRATING THE CENTENNIAL. Thanks to their shared heritage, the Maryland Forest and Park Services celebrated their centennial in 2006. Among the activities that paid tribute to a century of conservation and recreation in Maryland were the dedication of memorial plaques at College Park, Potomac-Garrett State Forest, and Deep Creek Lake, Wye Oak, Gambrill, and Patapsco Valley State Parks. Here former assistant POS director Offutt Johnson (left) and Green Ridge State Forest manager Francis Zumbrun (right) pose in front of a dedication plaque at Patapsco in May. Johnson and Zumbrun are respectively portraying Fred Besley and a 1930s forest warden. (Barbara Garner.)

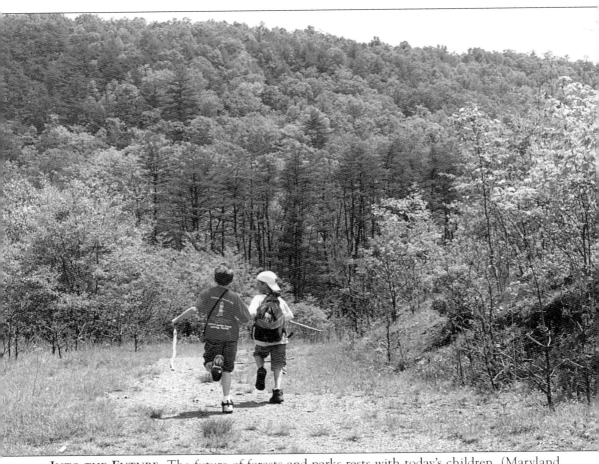

INTO THE FUTURE. The future of forests and parks rests with today's children. (Maryland Governor's Office.)

Appendix

Evolution of the Maryland Forest and Park Services
Board of Forestry 1906–1923
Department of Forestry 1923–1941
Department of Forests and Parks 1941–1972
Forest Service 1972–1982
Park Service 1972–1982
Forest and Park Service 1982–1984
Forest, Park, and Wildlife Service 1984–1991
Forest and Park Service 1991–2004
Forestry Programs 1991–1992
Forest, Wildlife, and Fisheries Service 1992–1993
Public Lands and Forestry, Forest Service, 1993–1995
Resource Management Services, Forest Service, 1995
Resource Management Service; Forest, Wildlife, and Heritage Service; Forest Service, 1995–2001
Forest Service 2001–present
Park Service 2005–present

State Foresters
Fred W. Besley (1906–1942)
Joseph F. Kaylor (1942–1947)
Henry C. Buckingham (1947–1968)
Adna R. Bond (1968–1977)
Donald E. MacLauchlan (1978–1979)
Tunis Lyon (1979–1983)
James B. Roberts (1983–1991)
John W. Riley (1991–1995)
James E. Mallow (1995–2001)
Stephen W. Koehn (2001–present)

State Park Directors
Karl Pfeiffer (assistant state forester) (1936–1954)
William R. Hall (1954–1956)
William A. Parr (1956–1964, 1972–1978)
A. J. Pickall (1964–1968)
William H. Johnson (1968–1972)
Donald E. MacLauchlan (1978–1986)
David Hathway (1986–1990)
Steve Scholl (1990–1991)
Rick Barton (1991–present)

BIBLIOGRAPHY

Association of American Forests. "Salute to Maryland." *American Forests Magazine*, October 1956.

Bailey, Robert, and Ross Kimmel. "Maryland State Forests and Parks." *Maryland Natural Resource*, 9 (2), Spring 2006.

Besley, F. W. *The Forests of Maryland*. Baltimore: Johns Hopkins University, 1916.

Buckley, Geoffrey L. and J. Morgan Grove. "Sowing the Seeds of Forest Conservation: Fred Besley and the Maryland Story, 1906–1923." *Maryland Historical Magazine*, 96 (3), Fall 2001, 303–327.

————, Robert F. Bailey, and J. Morgan Grove. "The Patapsco Forest Reserve: Establishing a 'City Park' for Baltimore, 1907–1941." *Historical Geography*, 2006, 87–108.

Landrum, Ney C., ed. *Histories of the Southeastern State Park Systems*. Washington, D.C.: Association of Southeastern State Park Directors, 1992.

Parker, Eugene Philip. "When Forests Trumped Parks: The Maryland Experience, 1906–1950." *Maryland Historical Magazine*, 101 (2), Summer 2006, 203–224.

Widner, Ralph R., ed. *Forests and Forestry in the American States: A Reference Anthology*. Washington, D.C.: The National Association of State Foresters, 1968.

Zumbrun, Francis, William Offutt Johnson, and Robert F. Bailey. "100 Years of Forestry and State Parks in Maryland." *The Glades Star*, 11 (2), June 2006, 51–62.

INDEX

DISCOVER THOUSANDS OF LOCAL HISTORY BOOKS FEATURING MILLIONS OF VINTAGE IMAGES

Arcadia Publishing, the leading local history publisher in the United States, is committed to making history accessible and meaningful through publishing books that celebrate and preserve the heritage of America's people and places.

Find more books like this at
www.arcadiapublishing.com

Search for your hometown history, your old stomping grounds, and even your favorite sports team.

Consistent with our mission to preserve history on a local level, this book was printed in South Carolina on American-made paper and manufactured entirely in the United States. Products carrying the accredited Forest Stewardship Council (FSC) label are printed on 100 percent FSC-certified paper.

MADE IN THE USA